SUBURBAN WORLD

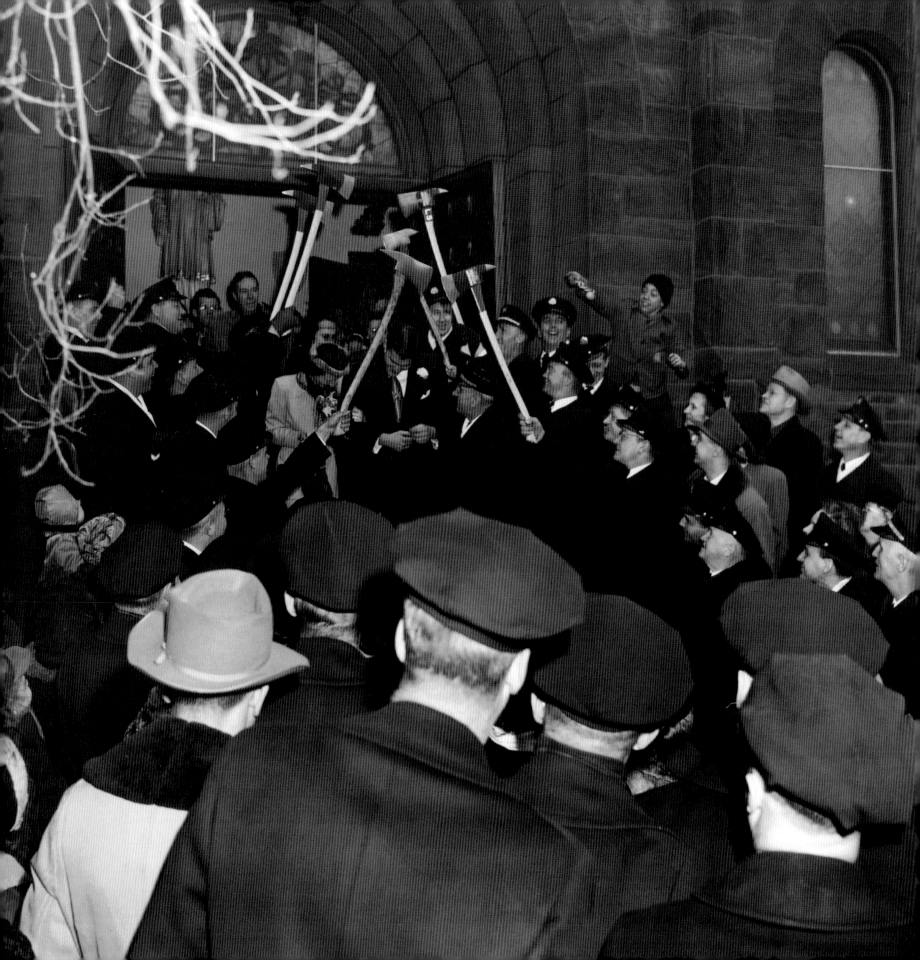

SUBURBAN WORLD
THE NORLING PHOTOS

BRAD ZELLAR

With a Foreword by Alec Soth

**BOREALIS
BOOKS**

Published in cooperation with the Bloomington Historical Society

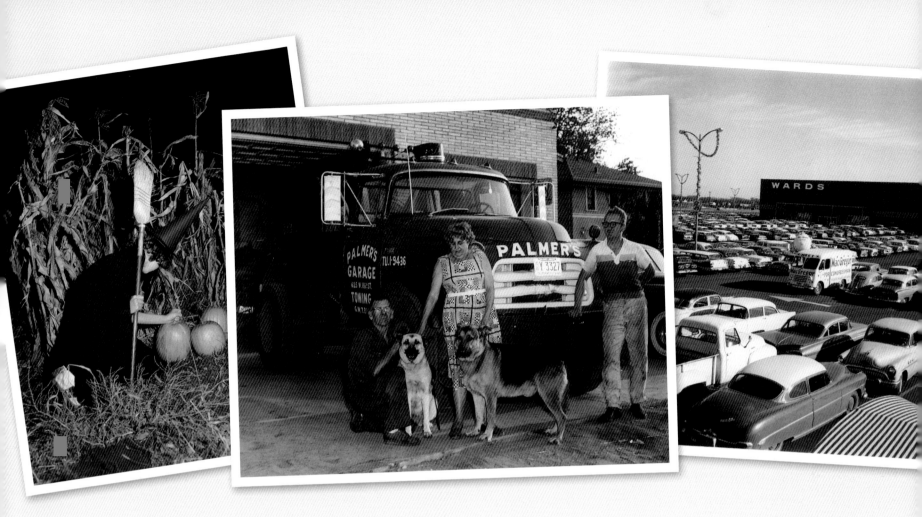

Borealis Books is an imprint of the Minnesota Historical Society Press.

www.borealisbooks.org

The Minnesota Historical Society Press is a member of the Association of American University Presses.

Cover and book design by Percolator Graphic Design, Minneapolis, Minnesota

Manufactured in China by Pettit Network, Inc., Afton, Minnesota

10 9 8 7 6 5 4 3 2 1

♾ The paper used in this publication meets the minimum requirements of the American National Standard for Information Sciences—Permanence for Printed Library Materials, ANSI Z39.48-1984.

International Standard Book Number
ISBN 13: 978-0-87351-609-9 (cloth)
ISBN 10: 0-87351-609-5 (cloth)

Brad Zellar first wrote about the Norling Archive in 2003 for *City Pages*.

The photographs on the front jacket (portrait) and on pages ii (fireman's wedding, 1949), 3, 5, 10, 17, 21, 25–28, 32–34, 44–47, 51, 56, 57, 65, 67 (top), 80, 81, 85, 88, 99, 105, 106, 109, 119, 124, 125, 131, 132, and 134 are courtesy the Irwin Denison Norling Family. All the other photos—including those on page iv (Halloween witch, 1959 [left]; Palmer's Garage, 1960 [center]; and Southtown opening, 1960 [right]) and on page vi (boy collector, 1956)—are courtesy the Bloomington Historical Society. Copies of some photos exist in both collections.

Library of Congress Cataloging-in-Publication Data
Zellar, Brad.
 Suburban world : the Norling photos / Brad Zellar ; with a foreword by Alec Soth.
 p. cm.
 ISBN-13: 978-0-87351-609-9 (cloth : alk. paper)
 ISBN-10: 0-87351-609-5 (cloth : alk. paper)
 1. Norling, Irwin Denison, 1916–2003. 2. Documentary photography—Minnesota—Minneapolis Region. 3. Photographers—United States—Biography. 4. Minneapolis Region (Minn.)—History—20th Century—Sources. I. Norling, Irwin Denison, 1916–2003. II. Soth, Alec, 1969– . III. Title.

TR820.5 .Z46 2008
779/.99776579 22 2007038172

ACKNOWLEDGMENTS

For Sheila Kennedy (and Willis), with love and gratitude always. Thanks and love also to Alison McGhee, for her support and assistance with this project. More love, more gratitude to all my family; Jennifer Vogel and Mike Mosedale; Julie Caniglia; Eric Anderson and Roger Beck; John Wareham; Dan Corrigan; Steve Perry; Nick Vlcek; Michael Tortorello; Britt Robson; David Rathman and Dani Werner; David Small and Sarah Stewart; Burl Gilyard; Amy Filipiak; Stuart Klipper; Mike Melman; Dutch Gaines; Chris Hesler; Karla Rydrych; Jeffrey Herman; everybody at *The Rake*. Huge thanks to Greg Britton, Marilyn Ziebarth, Ellen Miller, Will Powers, and all the folks at the Minnesota Historical Society and Borealis Books; and to Vonda Kelly and the Bloomington Historical Society. Special thanks to Alex Soth. And, finally, to Pat, Mike, and Dave Norling and their families, whose cooperation, patience, and enthusiasm were always much appreciated.

The publication of this book was supported, in part, by the Minnesota's Greatest Generation Project of the Minnesota Historical Society.

FOREWORD

Alec Soth

My first job as a photographer was with a suburban newspaper on the eastern margin of the Twin Cities. Like most small-newspaper photographers, the job required me to be a generalist. I photographed baseball games and small-business owners, parades and potlucks. Most of my time was spent in the mushrooming suburb of Woodbury. Almost every week I had to attend a ribbon cutting for another new health club or minimall. I dreaded these assignments. The lineup always looked the same: a banker, a mayor, a pair of giant scissors (or a silver shovel), and a dozen other guys in ties—an insult to my photographic artistry!

Each year we submitted our best photographs for a national small-newspaper award. I would ransack my proof sheets looking for a gem, and I remember being particularly proud of a picture of a silhouetted cross-country skier. But this photo, along with all my other submissions, never even took third place.

One year our elderly sports writer was driving home from a basketball game when he stumbled upon a peculiar automobile accident. Using his Kodak Instamatic, he snapped a picture of a car suspended in a tree. Though he didn't know the first thing about F-stops and art history, the old guy managed to win the newspaper association's coveted award for spot news. The "real" photographers were sick with envy.

That was when I learned that most great pictures are not about artistry. If I'd been the one to photograph the car in the tree, I'd have won the award. The genius is not in technique; it is in being present.

Irwin Norling was a great photographer because he was so often present. In the middle of the night, he'd grab his camera, pack the kids into the car, and head off to the latest crash. What makes the Norling archive thrilling, however, is that these grizzly spectacles are balanced with pictures of ordinary life. Norling didn't feel his skills were compromised when he photographed a ribbon cutting. All his subjects, whether house fires or city council meetings, were treated with a cool but clear-eyed presentness.

Picasso famously said that it took him a lifetime to paint like a child. It takes many professional photographers that long to strip their pictures of artiness. How humbling to realize that simple mechanical reproduction

can offer so much more than creative interpretation. Photographers such as Walker Evans toiled to avoid pretense. But working photographers like Lewis Hine, Weegee, and Norling never aspired to make art. From beginning to end, their motive was simple documentation. The pictures are solely about their subjects.

What makes Norling's images distinctive from those taken by the photographers just mentioned are the specifics of his subject. Irwin Norling spent his life photographing a single, first-ring suburb in the northern Midwest. In doing so, Norling makes Bloomington as distinctive and absorbing as Atget's Paris or Weegee's New York. While this might come as shock to Parisians and New Yorkers, he makes Bloomington just as meaningful.

One flaw in the record of documentary photography is its overreliance on exoticism. Photographers daydream about photographing brothels in India or insane asylums in Brazil. How many of these pictures do we need? No one would deny that photographers should be documenting the Middle East, but why not keep one or two in the Middle West. As Norling visually describes it, a place like Bloomington is mysterious. In this book we see a noose being attached to a mannequin, muscular men riding donkeys, a dozen teenagers with rifles. Even the less flashy subjects possess their own kind of oddity. The more time passes, the more those Shriners look like they came from an alien planet. As the great American photographer Gary Winogrand once wrote, "There is nothing more mysterious than a fact clearly described."

For me, the most extraordinary images are the portraits. Perhaps due to his own physical condition, Norling has a keen eye for weakness. In one picture we see a smoked-meat salesman. Although he's buttoned up for the camera, there is no hiding the sad eyes, scarred chin, and defeated shoulders. Another photo shows a young man in a T-shirt gazing at his model airplane. As with many of these pictures, it is hard to pin down his age. He could be sixteen or twenty-six. Either way, his look suggests a longing for boyish dreams of flight. But the weightlessness of the plane belies the beefy farm-boy physique.

One of my favorite pictures looks a like a sad sack's fantasy. Four bespectacled nurses are gathered around a hunky patient's bed. One raises a straw to his mouth, another caresses his pillow, a third looks down bashfully, and the last giggles at the lothario. I imagine Norling snapping away in envy.

On occasion Norling seems to be illustrating a fantasy version of midwestern life. A family gathers around Dad reading the Bible, Girl Scouts deliver cookies. But just as the farm boy will never fly, these Norman Rockwellesque scenes invariably segue to house fires and bruised bodies. The fantasies always butt up against cold facts.

Irwin Norling's pictures show a culture straining for order and joy. In one parade photo, we see Esther B. Bowles and her Happiness Troupe smiling with genuine glee. The weight of perfection, however, is sometimes too much to bear. In many photos, the smiles become strained. The weary cabbie in front of the *Bloomington Sun* newspaper office gets into his car. While we'll never know what awaits him—another parade or an automotive bloodbath—there is a good chance that Norling, and his kids, will be there. By devoting himself to the ignoble art of being present, Norling succeeded in making his Bloomington as rich and mysterious as anybody else's metropolis. ■

THE NORLING PHOTOS

Looking through the more than 10,000 photographs Irwin Denison Norling left behind, you get the impression that the man never traveled far from his hometown of Minneapolis and the southern suburbs where he settled with his family in the early fifties. That's not to say Norling never went anywhere. His orbit may have been relatively compact, but he covered a lot of ground all the same, put a lot of miles on a series of cars he could recite off the top of his head—and describe in great detail—into his eighties: '41 Chrysler, '49 Packard, '49 Cadillac, '53 Cadillac, '58 Chevy ("for the boys"), '59 Pontiac, '66 Toronado.

Norling was born with a rare form of muscular dystrophy, yet he was an obsessive and scrupulous rambler, and his camera apparently went with him. The territory he covered was certainly familiar; it was a world he'd grown up in and knew, even as it was transformed almost as fast as he could document the changes.

He did document those changes, though, and his photographs capture the same meteoric transformations and concomitant growing pains that were taking place all over the country at the time, as small towns that had existed for generations on the outskirts of major cities were rapidly outfitted with the sort of arteries and infrastructure—freeways, sewers, subdivisions, and strip malls—that would permanently remake them as metropolitan ancillaries.

As such, Norling's pictures provide both a sort of suburban taxonomy as well as a civics lesson in black and white, complete with a thorough exploration of the dark undertow that runs beneath even the sleepiest little towns. Norling's unflinching investigations of that undertow are precisely what make his collection of images seem so startling and even subversive today. If anything, the yin-yang nature of his archive provides a photographic counterpart to the work of *noir* writers and

filmmakers of the same period, and scores of writers and directors—people like John Cheever and David Lynch—continue to make careers out of trying to portray the uneasy dichotomy that Norling captured time and again.

BEYOND THE STRANGE JUXTAPOSITIONS, incongruities, and glimpses into shadows and dark corners, however, the world of Norling's work will likely look familiar even to an outsider. One of the marvels and pleasures of this comprehensive document of a Minnesota community is the archetypal nature of so many of the scenes Norling captured—weddings, confirmations, dances, baseball games, town council meetings, ribbon cuttings, rodeos, parades, pancake breakfasts, and parties. The Bloomington, Minnesota, of these photographs is located less than a dozen miles from downtown Minneapolis, yet there's little beyond the occasional local landmark to distinguish it from other similar towns almost anywhere in postwar America.

Norling spent a staggering amount of time staring at his little corner of the world—its light and darkness, tragedies and desolation, rituals of community and celebration—through the lens finders of his cameras and in the developing trays in his lab. Familiar as the people and places in those pictures may have been to him, there surely had to have been many times when the images that emerged in Norling's basement darkroom seemed startling, disturbing, or just plain strange even to the man who captured them.

Yet when pressed on the subject he would say without much hesitation, No, not really. Not that he could recall.

"Those pictures," Norling said. "That was the way it was. And the way it was, that's what I was after."

Near the end of his life, Norling would dismiss the notion that he had been an artist, and he candidly admitted that he'd never heard of a handful of photographers whose names I mentioned to him in passing by way of contrast or comparison. He clearly wasn't a man who spent much time contemplating art and its definitions. Still, I don't believe in accidental art. Anytime somebody sets out to capture an image or tell a story—and succeeds (whether through desire, hard work, luck, inspiration, or some combination of those things)—I'm willing to credit them with having created art. And though Norling may have been blessedly free of any anxiety of influence, his best photos—and he left behind many, many terrific photos—are clearly the work of a man who cared about what he was doing, who consistently challenged himself, and who took great pains to produce clear and visually interesting images. Norling's index is full of notes regarding negatives and prints that he deemed unusable, and he routinely rejected and destroyed images by the hundreds. Long after he had been forced to set aside his camera, he still had a difficult time looking at a single one of his photographs and pronouncing himself satisfied.

Sifting through Norling's archive, it's hard not to be struck by the similarities, however inadvertent and unintentional, between some of his most striking images and the work of older and contemporary photographers. There are all sorts of fascinating convergences. Most obviously, so many of Norling's photos from the 1940s and 1950s—particularly the car accidents and crowd scenes—simultaneously recall Weegee's New York (for example, check out Norling's shot of the scrum at a rodeo dance) and Mel Kilpatrick's collection of crash photographs from southern California suburbia of the same era. Some of his portraits—the newspaper reporter at his typewriter, for

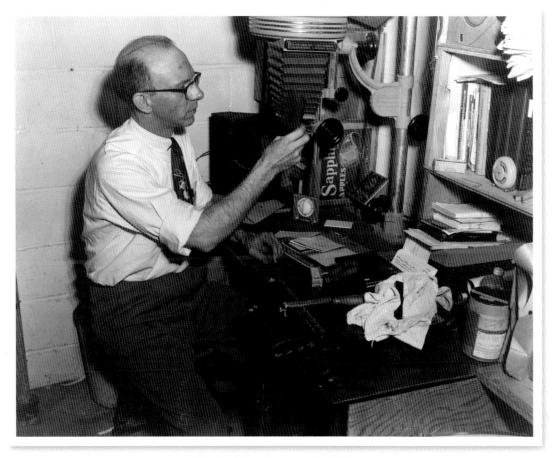

Norling in the darkroom, circa 1956

instance, or the police chief on the telephone—look like they could have been pulled right out of August Sander's monumental People of the Twentieth Century project; others might have come from Mike Disfarmer's studio in Heber Springs, Arkansas. Norling's numerous photos of desolate gas stations would look completely at home in Ed Ruscha's series of eerily similar pictures. And countless shots of everyday life in and around Bloomington suggest the street photography of Garry Winogrand and Bill Owens' own document of suburbia.

As I said, these convergences were surely unintentional on Norling's part, yet, all the same, it's hard to think of another photographer whose work could suggest similarities to so many different, and stylistically disparate, artists.

AFTER NORLING'S RETIREMENT, and after he moved into an apartment, his three children conferred with him and made the decision to donate the enormous cache of photos, negatives, and related ephemera to the local historical society run out of the old Bloomington town hall, right smack in the middle of the Minneapolis suburb

where Norling lived and took pictures for most of his photographic career.

When I stumbled across Norling's photos at the Bloomington Historical Society in 2002 they were being stored in a dank little basement room crowded with shelves and trunks stacked with all manner of inexplicable stuff. Historical artifacts of one sort or another, I supposed. In the midst of this ephemera and clutter were a couple of plain metal filing cabinets, each of them crammed with eight-by-ten-inch prints. Norling's negatives—mostly four-by-fives—were filed in a separate, smaller cabinet, all collated by number and date and immaculately indexed and captioned in a fat three-ring binder that sat atop one of the cabinets. The trail of captions, which commenced in the late 1940s and ceased in the early '80s, was fascinating, to say the least: Suicide at airport. Polio victim dancing with girls. Mrs. Hughes using chopsticks. Mrs. Don Anderson and turtle. Baby born with teeth. Accident, 78th and Xerxes, 13 injured. Paul Bunyan getting a Beatle haircut. Slugging at 90th and Penn. Joe Williams and mushrooms. Christmas party for retarded. Ruby Peterson found dead in yard. House exploding.

The sheer range of the subjects was mind-boggling. There were hundreds of portraits of Shriners, many of them posed like mug shots, as well as shots of donkey baseball games and enough horrific car crashes to fill several volumes. There were impossibly wholesome family Christmas-card photos, evidence photos from drug busts and murder scenes, and an exhaustive document of what seemed like the building-by-building development of Bloomington. The collection chronicled life in the Twin Cities' most ambitious suburb, from its days as a relatively isolated and self-contained little community along the Minnesota River to the postwar boom years that saw the construction of the highways and roads that would attract businesses and professional sports and put the city on the metropolitan map for good.

That afternoon I was not looking for Irwin Norling's photographs. In fact, I'd never heard of the man.

THE BLOOMINGTON HISTORICAL SOCIETY is still located in the original town hall, a handsome two-story building built at the end of the nineteenth century when the community had a population of just over 1,000. It resembles a country schoolhouse or church and looks out of place now, situated amid the sprawl of suburban office buildings and town homes. These days Bloomington is the fifth-largest city in Minnesota (the most populous suburb of the Twin Cities) and is perhaps best known for being home to the Mall of America, the most visited shopping center in the world.

When I was growing up in southern Minnesota in the 1960s and '70s, a trip to the Twin Cities generally meant a trip to Bloomington, where the 494 "Strip" (which still slashes across this city's northern border) was a major hub of metropolitan industry and activity. Met Stadium, the original home of the Minnesota Twins, was located along the Strip (on the site where the Mall of America now stands), as was the arena where the North Stars played their NHL games. The Strip was lined with restaurants, bars, and hotels—including the famous Thunderbird, one of the few surviving remnants of that era. For a time there was a Vegas-style showroom, the Carlton Celebrity Room (which the Coen Brothers immortalized in the movie *Fargo*), that hosted everyone from Rodney Dangerfield to Johnny Cash to James Brown.

On the Sunday afternoon I ventured out to the

Bloomington Village Hall, present home of the historical society. Undated

Bloomington Historical Society, I was looking for photos documenting the 494 Strip during that brief period when it was the local epicenter of bright lights and big city swank.

Like a lot of other similar first- and second-tier suburbs around America, Bloomington experienced a sort of dizzying historical acceleration in the second half of the twentieth century. Its little historical society—run by volunteers and, at least back in 2002, open for only a few hours on Sunday afternoons—had largely remained a repository of the town's early history, stretching back to the middle of the nineteenth century. There were lots of pieces of ancient agricultural equipment, Indian relics, military uniforms, old photographs, and recreations of period rooms from the settlement's earliest days. It was a nice collection of stuff, and I had a pleasant enough time poking around, but there was unfortunately precious little of more recent vintage.

The lone volunteer on duty that day was stumped. He did, though, make a phone call, and a moment later I was informed that somewhere in the basement there was allegedly a collection of contemporary images that

a local photographer's family had donated to the society some years ago.

Let's take a look, I said.

I followed my guide down the stairs and we poked around in a couple of storerooms crowded with boxes. We finally made our way to the last room at the end of a dark hall, and there I found the remains of Irwin Norling's obscure and obsessive lifelong quest.

I wasn't more than a couple hundred photographs into the first drawer of the file cabinet when I realized I was looking at an astonishing and remarkably comprehensive record of life in one American community. I spent the rest of that afternoon wading through those files, increasingly incredulous and overwhelmed.

The old fellow who was holding down the fort at the town hall that day had never heard of Norling and knew nothing about the collection. Who the hell was this guy? I wondered. And what in the world had I gotten myself into?

WHEN I DROVE HOME from Bloomington that afternoon and typed Norling's name into various Internet search engines, there were no matches. I tried the Social Security Administration's death registry as well, turned up nothing, and was encouraged to think that the old man might actually still be out there somewhere. A few days later I made an appointment to get back into the old town hall to take another look at the photographs.

If anything, the range and enormity of the collection was even more dizzying the second time around. I uncovered all sorts of marvelous photos I had somehow missed on my first visit.

I also discovered prints that were credited to other Norlings: June, David, Mike. Working from the index and its meticulous captions I noted that every photograph of the Norling family, along with the negatives, had been removed from the archive, the citations neatly crossed out with a marker. However, I did find one photo of the Norlings uncharacteristically filed out of sequence—a portrait of the family taken in a living room. In the photo a cord is clearly visible running across the floor from the direction of the camera and disappearing into the cushion of Irwin's easy chair; you can see the button for the self-timer clenched in his fist. Five people are in the picture—Irwin, June, Patricia, Michael, and David Norling, according to the inscription on the back—and a sleeping dog slumped at Irwin's feet. The camera's flash is reflected in the photographer's glasses, and the framing is slightly off—the classified ads from the Sunday newspaper are inexplicably splayed on the floor in the lower right-hand corner—making this family portrait one of the most incongruous photos in the entire Norling collection.

Over the course of a subsequent week I made calls to random Norlings in the Minneapolis phone book (for some reason, it never occurred to me that any of the family members, let alone the patriarch, might have defected to St. Paul), as well as to the suburban community newspapers and Bloomington City Hall, but I didn't have any luck tracking down information on the photo-grapher.

I eventually talked with Ron Whitehead, Bloomington's acting police chief. It turned out that Whitehead had gone to school with one of the Norling boys, and he remembered Irwin doing work for the department back in the day. He called me back later with a phone number for Dave Norling, who was living in a St. Paul suburb and working as a CPA. Even more astonishing, Whitehead in-

formed me that Irwin was still around and living in an assisted living facility somewhere in the Twin Cities area.

I tracked down Dave Norling a few minutes after I got off the phone with Whitehead, and he seemed both mildly amused and nonplussed by my interest. His father, he told me, was eighty-six years old and confined to a wheelchair, but was otherwise plenty sharp. "You'll see," he said, and he gave me Irwin's number.

When I called the photographer and chatted for a bit, I found him to be talkative, articulate, modest to a fault, and as sharp as advertised. If anything, he seemed even more bemused than his son at my interest in his photographs.

I met Irwin and Dave a few days later at the elder Norling's apartment in New Brighton, a St. Paul suburb. There were a few paintings on the wall, and I noted a cluttered desk and an old Commodore computer, which I learned Norling still occasionally used. There was not, however, a single photograph in evidence. And Irwin didn't look much different from the man in that 1956 family photo.

Both father and son had fond memories of Norling's photographic career (although there was clearly an unspoken "such as it was" implicit in their attitudes). It quickly became apparent, however, that Irwin never thought of taking pictures as anything but a hobby, albeit a hobby that spiraled seriously out of control. Because even though he shot thousands of photos of life (and death) in and around Bloomington and the southern suburbs for more than thirty years, and even though he spent thousands of hours processing those photos in his basement lab and sold pictures to newspapers, television stations, insurance companies, and lawyers, Norling was in essence a deadpan, self-effacing man, and it seemed to pain him to proclaim himself a professional photographer. He did have a long freelance association with a suburban newspaper, the *Bloomington Sun,* but for thirty-eight years ("Thirty-eight years, three months, and seventeen days," Norling would recall) he had been a largely self-trained engineer—a draftsman and tool and gage designer—for the locally based Honeywell Corporation; that, he made it clear, was his *real* job. The Honeywell check paid the bills, and allowed him to indulge his photography habit.

NORLING WAS BORN ON JUNE 8, 1916, at his family's home in south Minneapolis, where he grew up. The genetic form of limb-girdle muscular dystrophy that he was born with—which would not be officially diagnosed until 1975—would flare up and go into remission, and it eventually left him with a distinctive, rolling gait that was often described as resembling a sailor making his way across the deck of a boat.

Throughout his life Norling was consistently, obsessively precise regarding dates, times, names, and places, and more than seventy years after the fact he could recall that he had failed an English class in June 1930 and had to repeat it "starting September 2, 1930. The teacher was a Mrs. Thompson, room 316, sixth period, one PM."

Despite such travails, he graduated from Minneapolis's Roosevelt High School in 1935, in the midst of the Depression, and spent a number of years kicking around at various jobs.

"I was into a little bit of everything," he said. "My dad was having a hard time making ends meet, so I did whatever I could to help out. I hauled ashes to the dump, worked as a punch press operator, and sold insurance for Minnesota Mutual. For a time I worked at the

Electric Machinery Company in Northeast Minneapolis for forty cents an hour. I was six-feet-tall and skinny. I weighed maybe 150 pounds, and manual labor was hard for me."

He even did a stint as a "driver and companion" for a traveling clothing salesman whose beat included much of Minnesota, all of Wisconsin, and upper Michigan. In a brief autobiography he put together after his retirement, Norling wrote that the man had owned a "1935 Oldsmobile that in February of 1937 had 105,000 miles on it and still ran like a top."

He got his break at Honeywell on May 3, 1940, "at approximately 10 AM." Throughout his career he worked forty-hour weeks and took on all the overtime he could get. "Over the years," he wrote, "I was classified as a Learner, Class C, B, and A Tool Designer, Gage Design Group Leader, Technical Assistant to the Chief Tool Designer, and Associate Instrumentation Engineer—all of these titles for the same job with the same responsibilities."

Norling married June Rose Mills in 1943 (they were married for fifty-five years, and June died in 1998). In 1946 the couple, looking for a hobby they could pursue together, enrolled in an adult education photography class at a nearby junior high school. Chester Magnuson, a local Associated Press photographer, taught the class.

"I discovered that I had a natural aptitude for taking pictures," Norling said. "It came easy to me, and I really enjoyed the technical aspects. One thing led to another, and before long Magnuson would have to go out of town and I would take over the class for him. Eventually I started going out on assignments with him as well, tagging along and taking pictures. I can still remember the first time the AP sent one of my photos out nationwide.

It was a photo of a labor strike, and it went out under Magnuson's name, but it was still quite a thrill."

It didn't take Norling long to catch the bug in a big way, and by the time the family moved into a new house in Bloomington in 1953 Irwin had a police radio that he never turned off. "I was going out to shoot photos at all hours of the day and night," he remembered. "And all this time I was working eight hours at Honeywell, plus overtime."

All three of the Norling kids had been born before the Bloomington move (the couple's firstborn child, Robert, died five days after birth), and Dave, displaying his father's prodigious memory for detail, recalled that the family took possession of their new home on "January 25, 1953, my brother Mike's sixth birthday." The city was in the early stages of its boom period as the Norlings were settling in. Directly across from their house on land where Bloomington Kennedy High School would be built (Dave Norling would be a member of the school's first graduating class) was an active farm, and on one occasion the family returned home to discover a bull in their front yard.

Once established in Bloomington, Norling started to learn a bit about the business side of the photography racket. He began to submit photos to the *Bloomington Sun* newspaper. He also offered his services to the local police department, free of charge, and pretty quickly cultivated a mutually advantageous relationship with the BPD. "If they wanted photos," he said, "I always provided them *gratis*. A lot of these accident and crime scene photos would come in handy as evidence, and the cops eventually became my best salesmen. If an attorney or an insurance company wanted photos, the police department would refer them to me, and these people would have

to pay for them. I'd always enjoyed taking pictures, but I discovered that I liked it even more when I realized I could make some money at it, and I learned to be a pretty tough negotiator."

In the early days (before local police departments had staff photographers or much, if any, forensics training) Norling would often be called to an accident scene to document evidence—location, relevant road signs, skid marks, the condition of roads and vehicles. "I learned pretty early on that thirty feet of skid marks were a whole lot more interesting as a photograph if there was a wrecked car sitting at the end of them," Norling said.

Judging by his photographs from this period, the mid- to late-'50s, the roads around Bloomington were mean streets indeed. Much of Norling's early work predates the construction of the major highways and roads that now skirt and cut through the city, and his archives are crammed with grim, noirish documents of head-on collisions along dark two-lane roads littered with impossibly tangled vehicles, auto parts, and bodies.

AS NORLING'S PASTIME made greater demands on his time, it became a family affair. "When that police scanner went off, it didn't matter what time of night it was," Dave Norling said. "In a matter of minutes all of us were up and dressed and in the car."

Dave's older sister, Pat, recalled the drill as well. "I think all of us could go from dead sound asleep to fully clothed with our shoes tied in under a minute," she said.

There were occasions when the family would beat the police to an accident scene, which was, Pat said, considered somewhat bad form.

From the very beginning June Norling took photos as well, and the kids started shooting as soon as they were old enough to hold a camera. Irwin did most of his early work with a big four-by-five Speed Graphic camera, a cumbersome, wholly manual piece of equipment that could only hold two pieces of film at a time, one exposure on either side of a Bakelite holder that needed to be flipped between shots. The hot flashbulbs had to be changed after every exposure.

"We had seven police radios at home and radios in every car," Mike Norling said. "Dad had a rack of radios in his den, and they were connected to speakers all over the house. You couldn't get away from it." The middle of the Norling children, Mike now lives in Virginia where he does classified work for a defense contractor after retiring from a twenty-six-year career as a photographic analyst for the Army and Air Force. "We were always rockin' and rollin' 24/7. It was a thrilling, adrenaline-pumping thing. Dad literally slept with a scanner under his pillow, and the emergency tone on those police radios was like an alarm clock. We all sort of developed a sixth sense. The radio would go off and we'd all run out in the dead of the night. The first one out of the house got to ride shotgun with Dad."

June and the kids would tote the gadget bag, shuttle film back and forth to the car, and generally serve as Irwin's gofers. Irwin had a collection of light-sensitive solenoids and would send the kids out to ring the accident scene. "We'd spread out for fifty or sixty yards," Mike recalled. "And when Dad would shoot, his flash would set off all these solenoids so we could illuminate a huge area."

"We'd all take pictures," Dave said. "But we were really there for one reason: to be Dad's legs and to help out with whatever he needed."

THE EXPERIENCE OF ACCOMPANYING their father to car accidents, fires, and crime scenes in the middle of the night surely made for a curious childhood. All of the Norling kids confessed to having witnessed breathtaking carnage at an age when most of their peers were still playing with dolls and toy soldiers. Mike recalled that he was six years old when he shot his first fatal accident. "That's sort of my claim to fame in the family," he said. "I wasn't feeling good one Sunday, so Dad and I were in the car out in the parking lot while Mom and

Dave and Pat were in church. An ambulance went by, so Dad and I went after it. We came upon a fatal accident, so instead of going to church I was taking pictures of a dead body with my little Brownie Hawkeye."

Pat, who is now the head reference librarian at the Mayo Clinic's Plummer Library in Rochester, didn't see her first dead body until she was ten. "I was never particularly interested in taking pictures," she said. "Given a choice between eating and reading I would have chosen reading, but going to accident scenes was pretty much unavoidable in our family. I remember my first fatal accident so well I could pretty much draw the whole scene in my head. It was a Sunday afternoon in the summer, and two stewardesses missed a curve on Old Shakopee Road going into the airport. The car rolled and one of them was thrown from the car and killed. I don't suppose you forget something like that."

Dave said that he saw and photographed so many casualties that he can't even recall the first one anymore. "They all just kind of blurred together after a while," he said. "We all understood from a very early age that this was an important job. It was just a way of preserving evidence and documenting a moment, and in time it became sort of matter-of-fact. You had to learn to disassociate yourself emotionally from the scene or you couldn't do it."

"I suppose we looked at life a little bit differently than other people," Mike said. "Between running around in the wee hours and hanging out down in the basement, we were a family that spent a lot of time in the dark. But we knew what we were doing was serious business. We were all at the dinner table at six o'clock every night, and we'd sit there for an hour, hour-and-a-half, talking about stuff, hashing things out. These conversations were lessons. Dad was a great teacher. You didn't necessarily

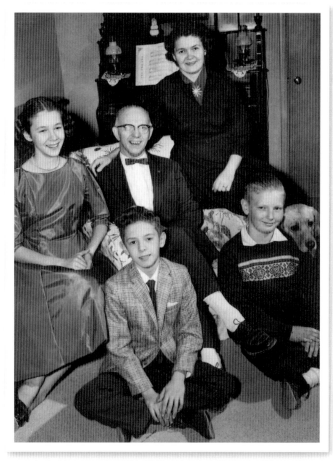

Norling family photo: Irwin, June, Pat (on left), Mike (in front), Dave, circa 1955

realize at the time that you were learning, but you were."

For his part, Irwin Norling professed to be unfazed by the grim tableaus he often saw through the lens of his camera. "I was solely interested in what sort of information the photos needed to convey if they were going to be of any use to the police department, or in the event that they ended up as court exhibits," he said. "I tended to keep my distance, but if a close-up had some bearing on a story, I'd get it. If there was an open beer can on the front seat, I took a picture of it. When I looked into a camera, I was looking for what was there. I wanted the photos to tell the truth, and it wasn't my job to get in the way or try to get too cute."

JIM BREKKEN IS A RETIRED Bloomington police chief and a member of the department from 1954 to 1989. His time with the BPD coincided with Norling's days as the city's unofficial police photographer. "Those were simpler days," he said. "Most departments then didn't have a crime-scene investigator, and Irv took pictures for us, and always did a terrific job. I guess you would say it was an informal relationship, but he really was invaluable. If you had any sense of Irv you know that he was a very brilliant, very sensitive person. He always seemed to know when his presence was appropriate, and knew how to do his work respectfully and unobtrusively. You were aware of his physical limitations, but he knew how to work around them, and they never seemed to get in the way of what he wanted to do. He was almost always around in those days, but for the most part you'd never even know that he was there. Other people—particularly when you started having to deal with television people—you'd practically have to grab them by the scruff of the neck to get them out of the way, but Irv wasn't like that."

Brekken credits Norling with teaching him photography. "I used to spend a lot of time at his house and down in his studio," he said. "I learned a lot from him. He had a gift for capturing the right angle and the right light, and he really cared about what he was doing. He used to say that a bad print should never see the light of day. As the department grew we started to train people as evidence technicians, and we offered classes on photography that Irv and I taught together. He was very much in his element teaching, and would work patiently with someone just as long as he sensed that they really cared about what they were doing."

There aren't a lot of Norling's old BPD comrades still around, but Jerry Ruehle is another retired Bloomington officer who has fond memories of the photographer. Ruehle was with the department from 1956 to 1989, and in that time, he said, he worked every job with the exception of "kiddy cop."

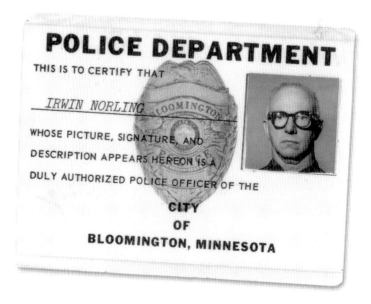

Norling's honorary Bloomington Police Department identification

11

"Whenever I worked nights I'd run into Irv," Ruehle said. "He'd show up at just about every call. I don't know if the guy ever slept. It could be three o'clock in the morning and he'd be there. He never charged the department for photos we could use. Anything we wanted, we could have, no questions asked. We'd often stop by the Norling house in the middle of the night. They always had the coffee pot going, and we'd sit around talking and listening to the police radios waiting for another call."

In Ruehle's time on the force, he said, the department grew "from twelve people when I started to 110 sworn officers when I left." In the early days, however, there might be only one or two cars working in the wee hours, and Ruehle remembered many occasions when Norling would beat him to the scene of an accident. "I might be working way across town," he said. "Irv would hear the call on his scanner, get up and go, and he'd already be shooting by the time I got over there."

On one memorable occasion, Ruehle got a late-night call about a dog that had fallen into the basement of a house under construction. "I was probably one of two cars that were working that night," he said, "and I went over there, climbed down into that dark basement after the dog. It was a big, friendly thing, and I picked it up and carried it up a ladder. When I got to the top there was smiling Irv Norling with his Speed Graphic and a flash. I didn't even know he was there. That photo of me with that big dog in my arms and a surprised look on my face made the rounds of the department for a long time. It's probably still hanging up down there somewhere."

JUNE NORLING NEVER LEARNED TO DRIVE, and Pat never developed much interest in taking photos herself. "I may not have been into the actual photography part of it," Pat said, "but I got to be a pretty good lab rat in terms of processing. I spent an awful lot of time down in that darkroom, and I can still smell it. Mom took lots of pictures for the *Bloomington Sun*—garden clubs and community events and things like that—and the reporters used to come by the house and drive her around with them."

Mike and Dave clearly caught the bug from their father, and before they were old enough to drive they would race around Bloomington to accident scenes on their bikes. By the time they had cars of their own (outfitted, of course, with CB radios and police scanners) the boys were often meeting their father at accident scenes, or even beating him there. "Dad bought us the cars with the money he made off his photography," Mike said, "with the proviso, of course, that these were going to be working cars, and that we were going to go out there and take pictures. We were putting thousands of miles a month on our cars, and running up incredible gas bills at a time when gas was a quarter a gallon."

With so many family members in on the hunt, the actual images started going out to newspapers bearing the ambiguous credit, "Photo by Norling."

One afternoon when Mike Norling was sixteen and had just started driving, a phone call came to his school. "If something came up and Dad was at work," he remembered, "the police would call the school and the principal would come and get me out of class to go take the pictures. He'd show up and hand me an address, and off I'd go.

"So this one day he shows up at the door of my class and tells me there's been a murder-suicide in Bloomington and they need me to go over there to take pictures. I get over to this house and there are all these photographers and reporters from the big newspapers and

television stations standing around outside, and this police sergeant comes to the door and waves me in. I went in there and took the pictures, and when I came back out all these other guys are wondering what the heck is going on. What's this kid doing here?"

"Mike was a big boy that day," Irwin said when recalling the incident. "Here are all these other guys who are old enough to be his dad, and they're peppering him with questions and he just says, 'Sorry, fellas, you'll have to talk to the police.'"

IF ALL IRWIN NORLING HAD DONE was haunt accident and crime scenes, he still would have left behind an astonishing photographic record. But what distinguishes the Norling collection is its startling range, the juxtapositions and contrasts that emerge again and again—small-town scenes so impossibly wholesome they look like Hollywood movie stills that will segue abruptly into visions from the darkest noir.

"Dad was very civic-minded," Mike Norling said. "It was really important to him to be involved in the community, and he mentored a lot of younger guys to get involved as well. Over time he built up all sorts of connections around town, and as a result we got exposed to all sorts of interesting people. He turned our two-car garage into a studio so he could take portraits, and if something was going on he wanted to be there."

Norling was a Mason for forty years, and served as president of the local Lions Club. He was also an active member of the local Episcopalian church and a founder of the city's emergency communications department. All of these associations, along with his ties to the police and fire departments, provided additional opportunities to snap lots of pictures and make a few bucks. During a

time when Bloomington was experiencing rapid growth and development—building highways, courting industry and major league sports—Norling was in the middle of it all, documenting the city's transition from small American town to adjunct of a burgeoning metropolis. This transformation is one of the abiding subjects of Norling's photos.

Bloomington's growth was extraordinary even by postwar boom standards. From 1940 to 1950 the population had grown from 3,647 to 9,902; by 1955 the city had almost 30,000 residents, and five years later it had climbed to 50,000. Between 1953 and 1963 the city built sixteen new schools, and when its population finally peaked at 82,000 in 1970, Bloomington had forty-four churches, two professional sports facilities, a dozen shopping centers, and seventeen hotels. The place was barely recognizable from the town the Norlings had moved to less than twenty years earlier.

Yet above and beyond any hopes Irwin might have had to make money off his photographs, he seemed to have recognized the significance of what was happening in Bloomington and felt compelled to document it. Late in his life he admitted that he had made nothing off a huge percentage of the photographs he took over the years.

"Irv was very aware of and interested in all the changes that were taking place," according to Jim Brekken, the former Bloomington police chief who had known Norling for decades. "He very methodically set out to paint a picture of the changes that were taking place, and he was able to capture those changes in a very dramatic way. He showed up everywhere. It was a very unique and challenging situation in those days, and you had to be blind not to recognize that things were moving

very quickly. Irv's pictures showed what all that growth and change looked like as it was happening. And he was terrific at capturing humanity, warts and all."

Norling compiled a chronological index for every photograph he took, which included an elaborate "Assignment and Coding Procedure" that he revised periodically from 1954 until 1987. Composed of hundreds of numbered, handwritten pages, it provides a glimpse of not only his meticulous methods but also of the incredible range of his subject matter and curiosity. His system of organization is so thorough and complex that it almost has to be seen to be grasped. I've looked at it hundreds of times and it still boggles my mind. There are categories, and sub-categories, and sub-subcategories: Buildings (old buildings, current buildings, under construction, commercial, industrial, homes, churches, schools, etc.); Government (administration, police, fire, public works, engineering, emergency management, water and sewer, parks and rec, school system, other); Accidents (vehicular, nonvehicular, aircraft, boats, pedestrians, buildings, fires, explosions, other); People/Groups/Events (adults, weddings, parties, concerts, teenagers, children, babies, birthdays, weddings, anniversaries, parades, other); Groups (Lions Club, Optimists, Jaycees, Kiwanis, Rotary, Masons, American Legion, VFW, Garden Clubs, other). Every entry includes a negative number, date, and caption.

Norling's index alone is an obsessive monument, and it raises the question of how, in the midst of raising a family and holding down a full-time job, he managed to devote so much time to something he insisted on thinking of as a hobby.

"I don't think he ever went to bed before 2:30 in the morning, and even then he'd often get up in the middle of the night to go take pictures," Pat Norling said. "The only time I ever remember him going to bed early—it was maybe 11:30—he got something like forty-five minutes of sleep before the scanner went off and he ran off to a fire somewhere. He'd leave the house at 7:25 in the morning for Honeywell, punch the clock at 8:00, leave at 4:30, come home, read the paper, eat dinner, and then head downstairs to his studio."

Norling retired from Honeywell in 1978, and about the same time he started to cut back on his photography. He'd been slowing down for a number of years by then; he could never entirely embrace 35-millimeter film and didn't have much use for color photography. He had always enjoyed doing his own processing and hated the idea of turning over his film to commercial labs. He and June had also purchased a twenty-two-foot Winnebago, and they wanted to travel.

"In the years before Papa retired, the entire nature of his world had changed," Pat said. "In the beginning he looked at photography as social networking on a grand scale, but Bloomington was no longer the same place, and I think after a time he just wasn't as driven anymore. It was getting very difficult for him to walk any distance by the time he retired, and there were other things he wanted to do. He loved to read, and after he left Honeywell he spent the first year or so reading everything he could get his hands on. He was a big Louis L'Amour fan, and also liked science fiction."

BY THE TIME I MET IRWIN NORLING, June had died, and he was no longer physically able to travel or operate a camera. As we talked about his photographs I remember that I made the ridiculous mistake of asking him about his aesthetic. He scoffed openly and professed that he had little idea what the word meant. He also said he had

never spent much time looking at the work of other photographers.

Nonetheless, Norling's photos do have a consistent style, marked by a slight standoffishness and a perfectionist's obsession with framing. There's nothing quirky or self-conscious about his work; if anything, there's a stubborn reticence that calls attention to itself through the photographer's refusal to intrude on the scenes he's documenting. With very few exceptions Norling's photographs were all taken around the community. He rarely strayed outside Bloomington and the surrounding area, and whenever he did he apparently didn't feel compelled to take photographs. His darkroom was in his basement, and he preferred to do his own processing, or to delegate it to the other members of his family. There was no one, he said, that he could point to as an influence; the only other photographers he was concerned with were the locals he ran into when he was out shooting.

What drove him, he admitted, was the desire to beat those guys at the big papers, guys who had once upon a time denied him membership in the local professional photographers' association because he didn't make at least half of his income from photography. "I never considered myself a professional photographer," he said. "But I was sure competing with professionals, and it was a point of pride to beat them on a regular basis. There was nothing I liked better than to get to a scene and shoot my pictures, and then when the guys from the big papers showed up I'd say, 'What took you so long?'"

Back when he was just getting started taking photographs, a taxicab clipped Norling while he was standing in the middle of an intersection taking pictures of an accident scene. He ended up missing a day of work at Honeywell, and when his boss asked him why he had to take pictures, Norling told him, "Some people like to fish, others like to hunt. Me, I like to take pictures."

During his stint as a freelance photographer with the *Bloomington Sun* in the 1950s, Norling was paid $2.50 for every picture they used, and he could often make in the range of $150 a month.

"It was mad money," Norling said. "The Honeywell check went right to my wife, and whatever I could scrape together from the photography went into my pocket. It paid for the kids' educations and bought their cars, so it was good for something. And there was always a challenge to it that I enjoyed. A camera tells it like it is, and what it usually boiled down to was that I was taking still-life photographs. Sometimes literally so. I'd be taking photos today if I could still lift the damn camera."

IRV NORLING DIED ON FEBRUARY 5, 2003. His funeral, at St. Christopher's Episcopal Church in Roseville, was an appropriately modest affair, attended by a small gathering of family and friends. Norling's ashes sat at the front of the church in a plain cardboard box with a white paper label bearing his name affixed to the top with packing tape. The minister at the service admitted that she had never met Norling. She mentioned his interest in photography merely in passing. After the service Mike Norling assured a concerned child that Irwin would eventually get a better box. As for his father's legacy, Mike recalled calling Pat in Rochester and being oddly stirred to hear the reassuring squawking of a police scanner in the background.

Looking through the photos today, the Norling archive has the effect of a time-lapse historical newsreel. The critic Walter Benjamin, who understood better than anyone the disorienting power of photography (as well

as time's ability to obliterate the memories that photos strive to preserve), once wrote that the "outskirts are the state of emergency of a city, the terrain on which incessantly rages the decisive battle between town and country." In Norling's photos you see the town of Bloomington losing that battle, step by step. County roads become freeways. A charming old general store burns, and you see sports stadiums and shopping malls and the bland, unmistakable signposts of modern suburbia taking over what had once been countryside. In the contrast between the most intensely private moments—the unspeakably lonely spectacle of dead bodies on dark roads, or of a priest performing last rights—and the corniest and most archetypal public events, the Norling photographs capture a blurred and uneasy middle ground between imagination and experience, dreams and reality, and the past and the future. A present, in other words, that is always slipping away at shutter speed. ▧

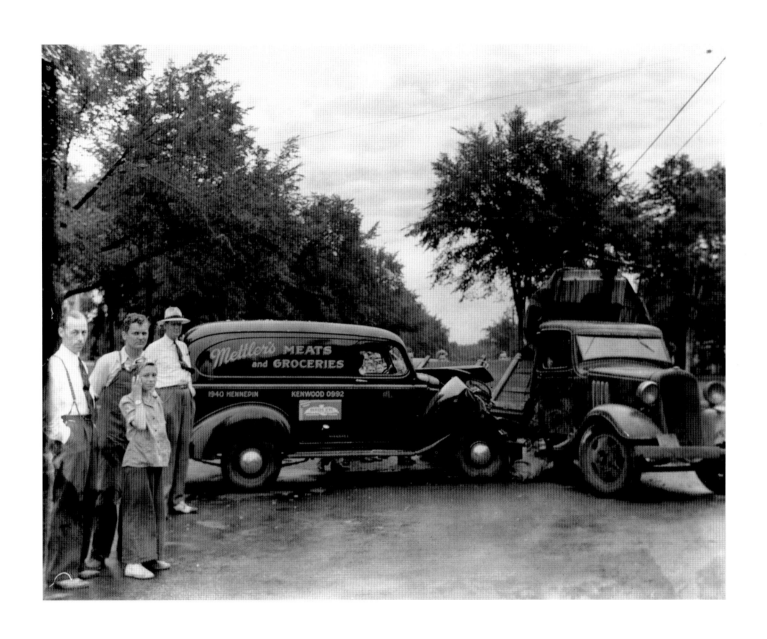

First accident photo, circa 1941

Lyndale Avenue and Old Shakopee Road. 1958

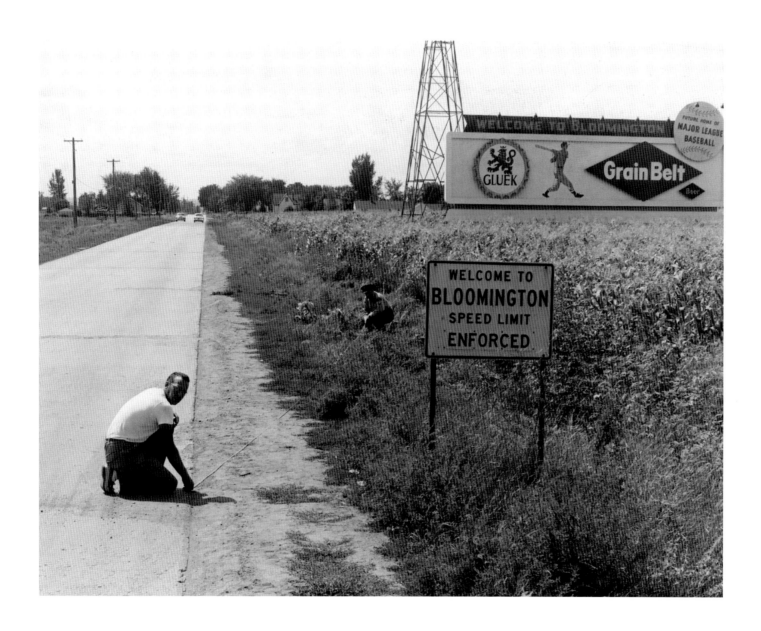

Welcome to Bloomington, Future Home of Major League Baseball. 1955

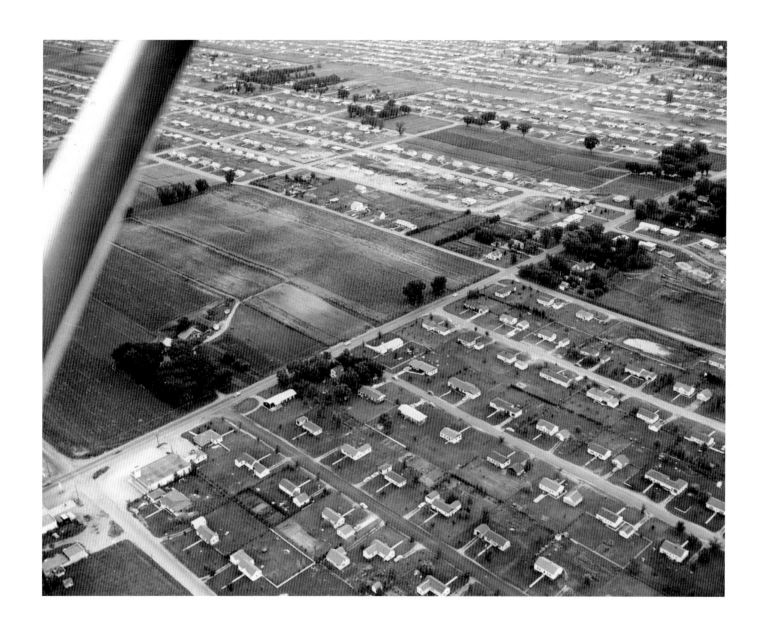

Above Bloomington. 1956

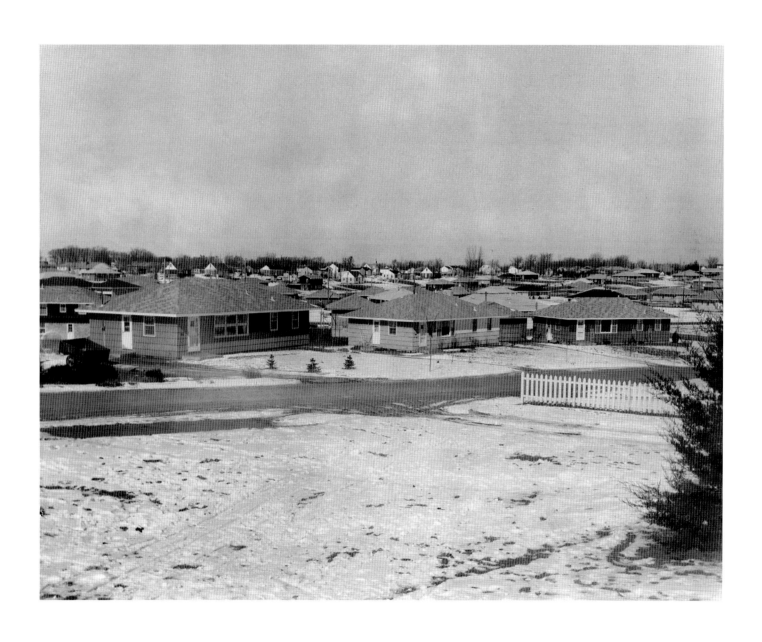

Suburban development. 1960

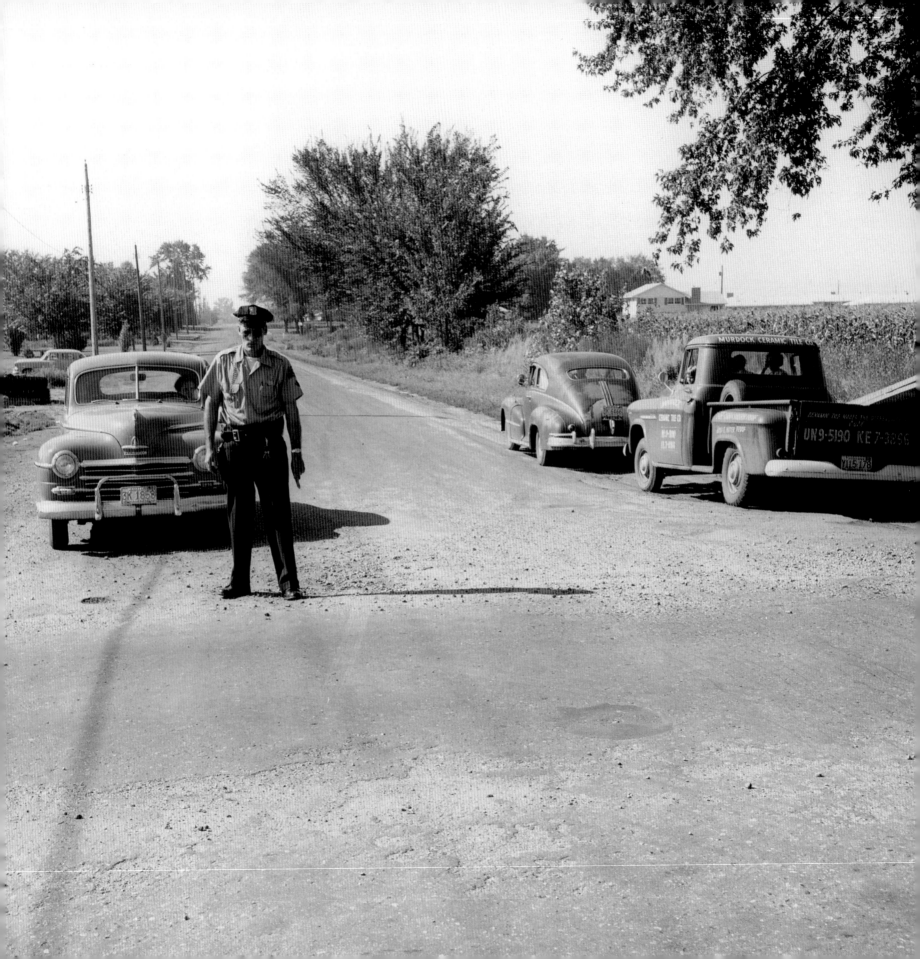

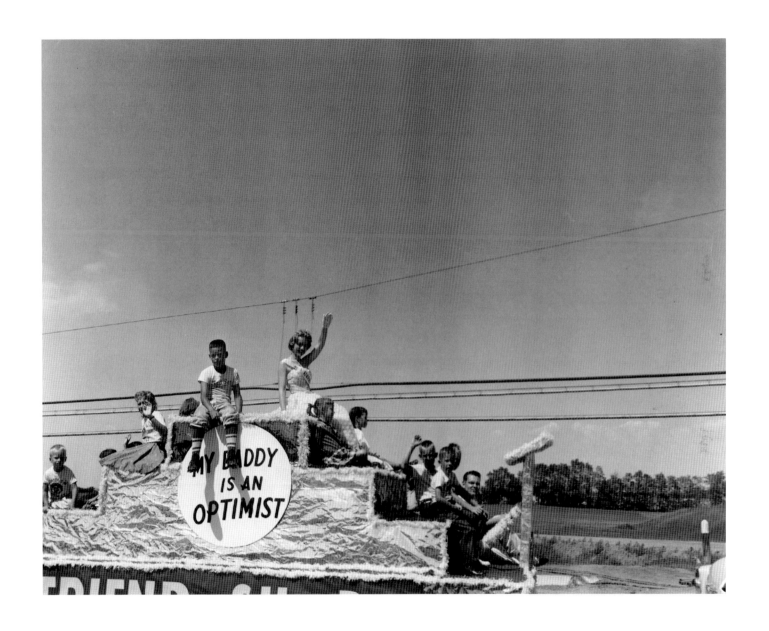

Bloomington Centennial parade. 1958

FACING PAGE: Old Shakopee Road and Portland Avenue. 1957

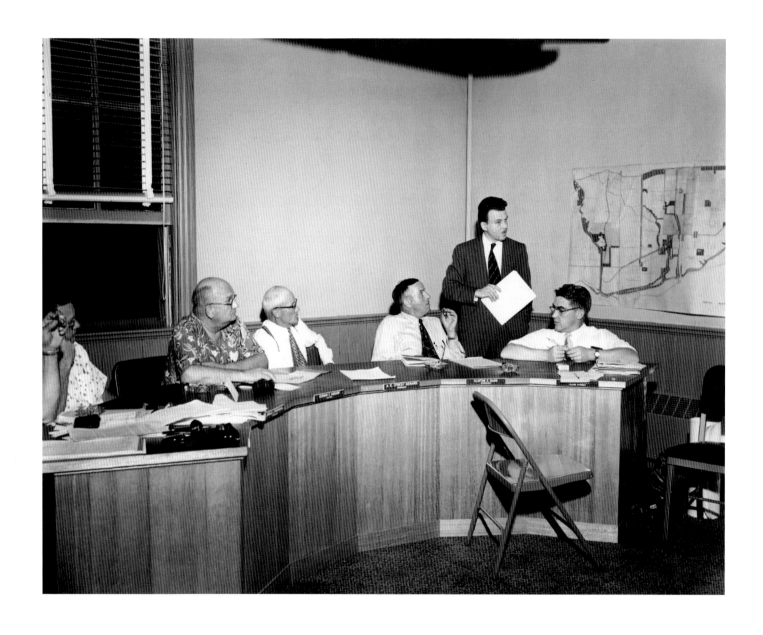

Village Council meeting. 1954

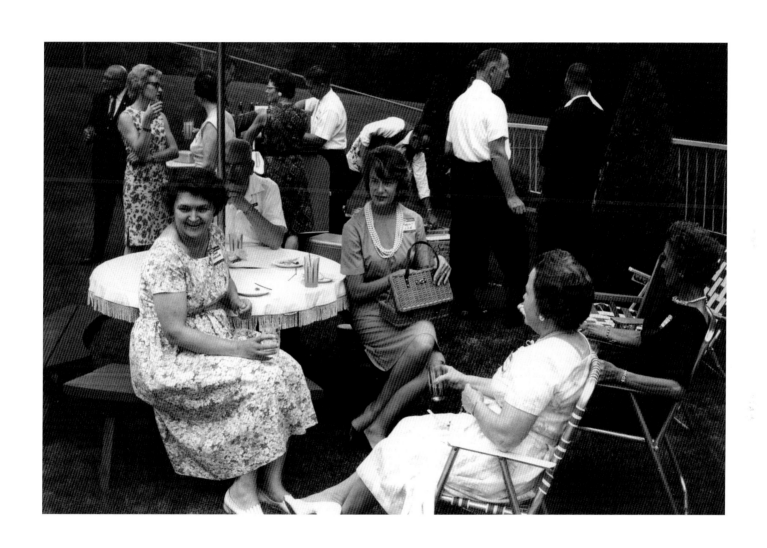

Pool party. 1963

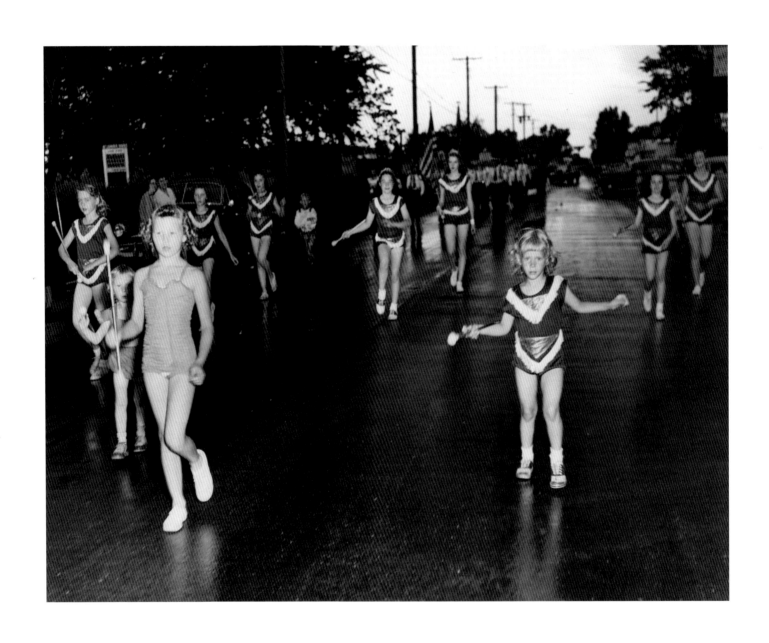

American Legion parade, Barbara's Dancing School. 1954

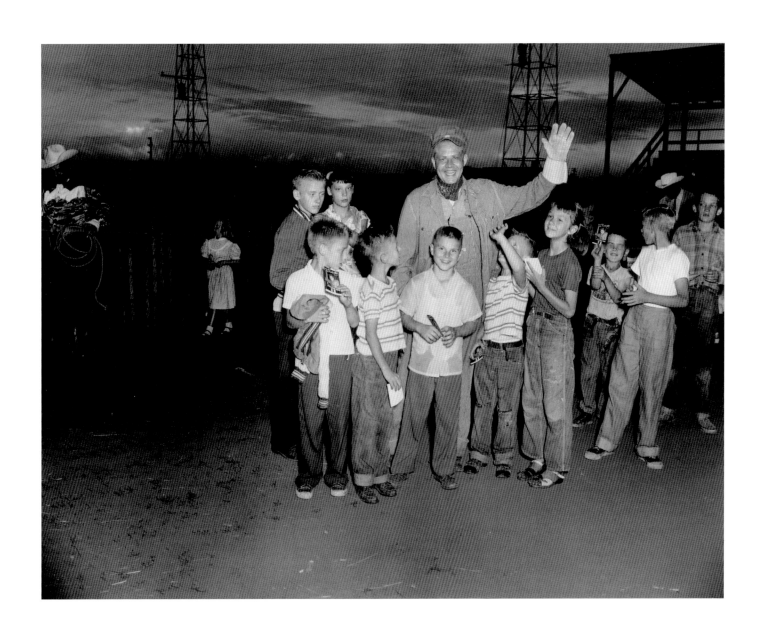

Local TV star Casey Jones at Lions Club rodeo (Mike and Dave Norling in striped shirts; Pat Norling just below Casey's waving hand). 1955

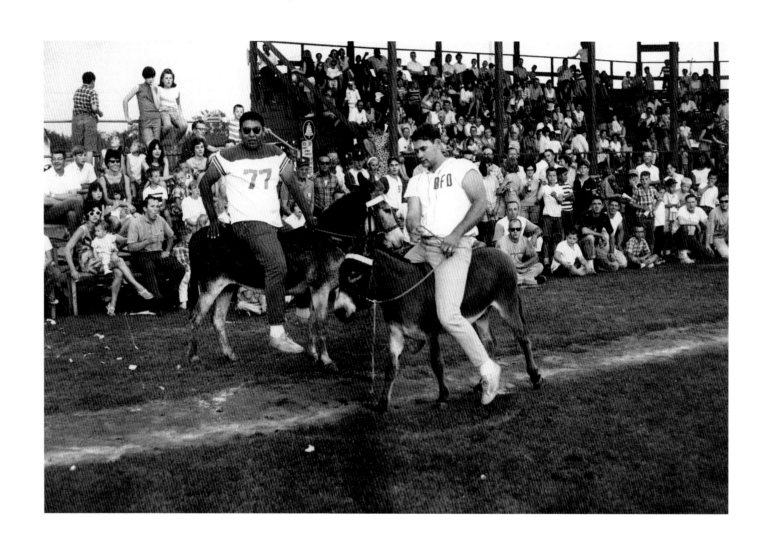

Donkey baseball game, BPD versus BFD. 1968

Lions Club rodeo dance. 1956

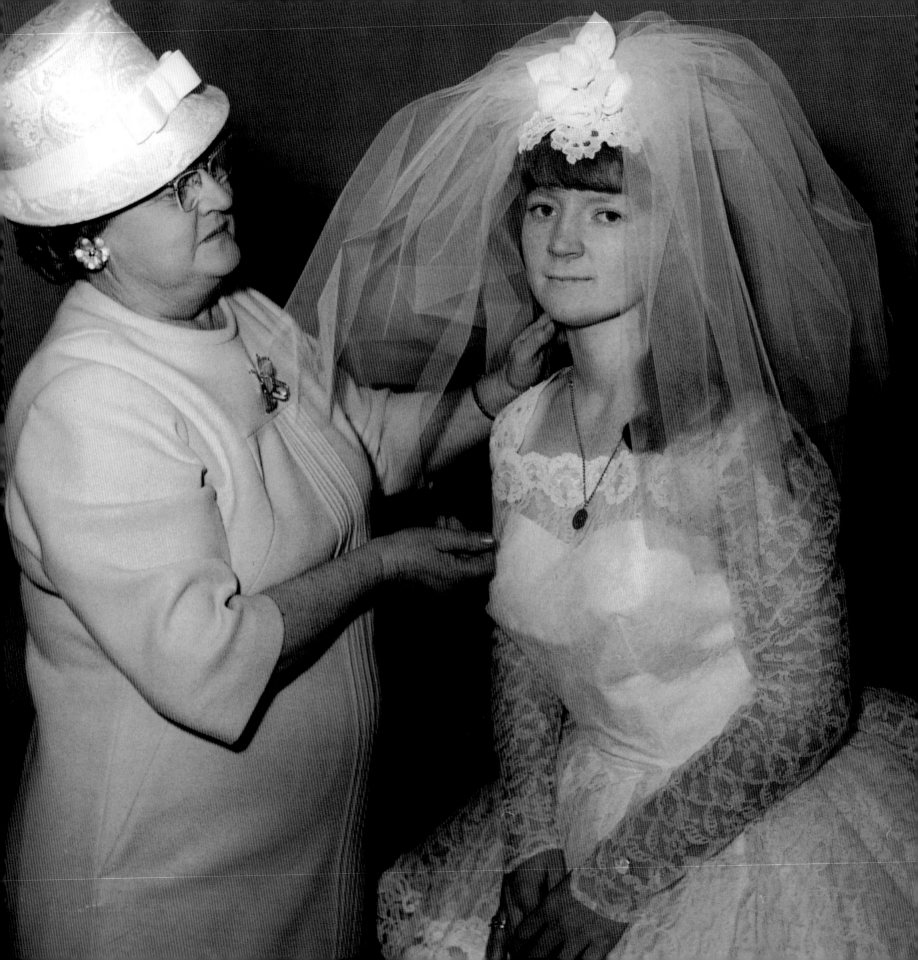

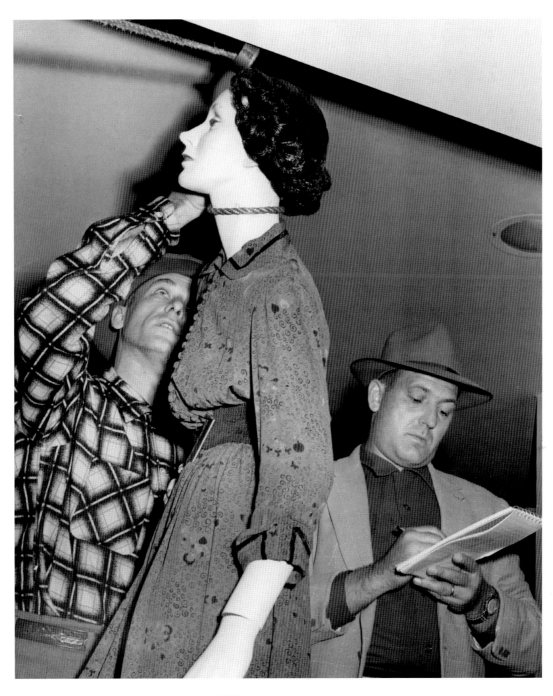

BPD training exercise. 1955

FACING PAGE: Wedding. 1969

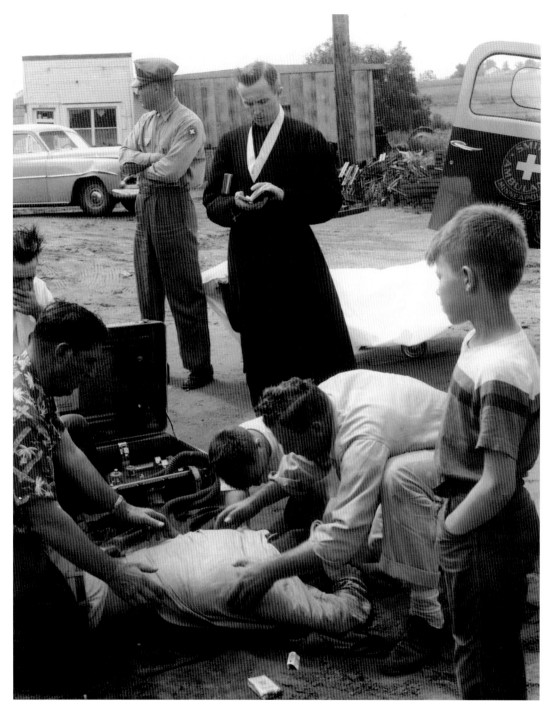

Electrocution, last rites. 1955

Barbara Ruehle. 1964

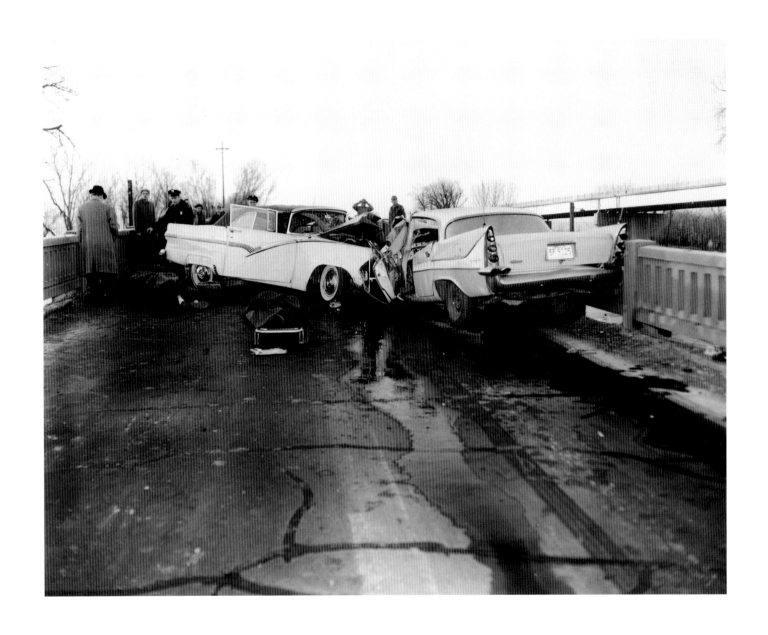

Fatal accident, Minnesota River Bridge. 1960

FACING PAGE: Used car lot, 96th Street and Lyndale Avenue. 1957

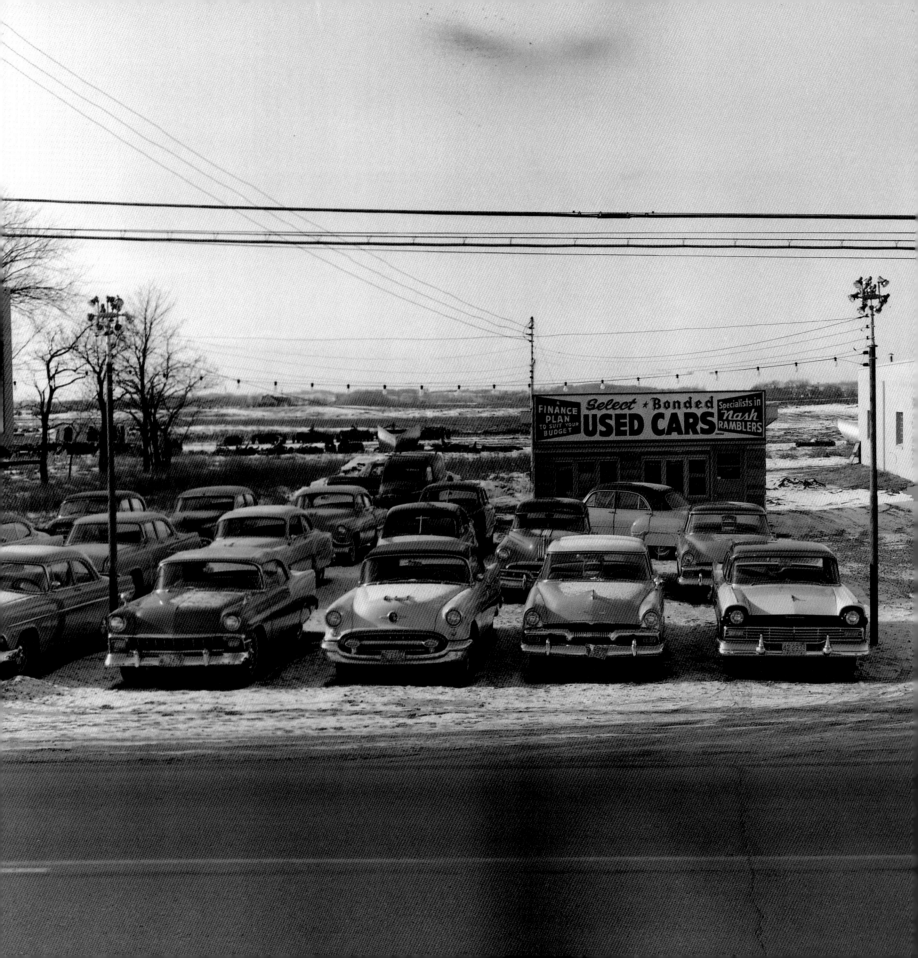

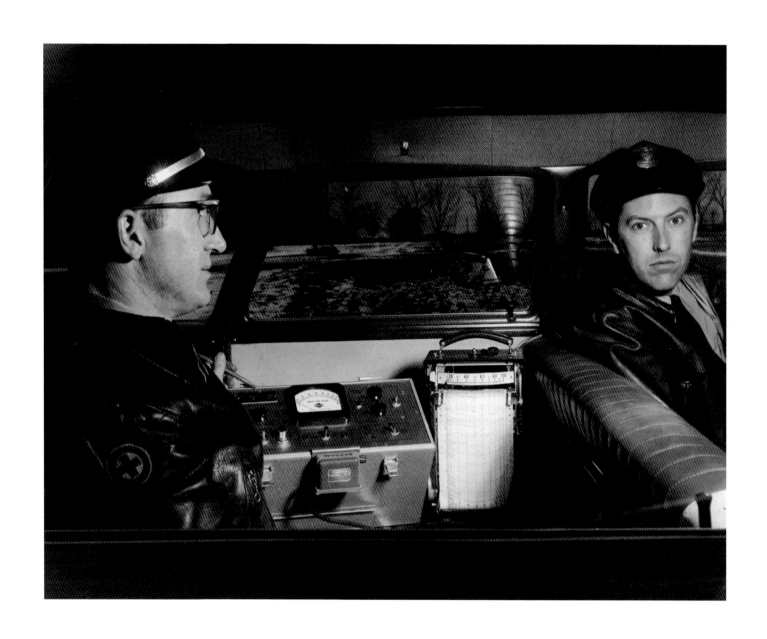

BPD officers Paul Block and Jim McMahon with Trafficorder. 1958

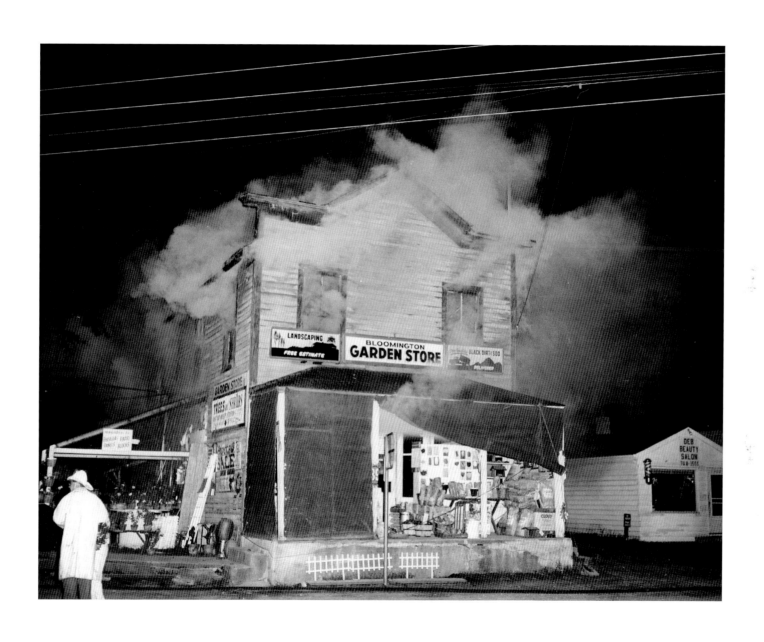

Fire, Bailiff Store (once owned by Mike Todd's father). 1958

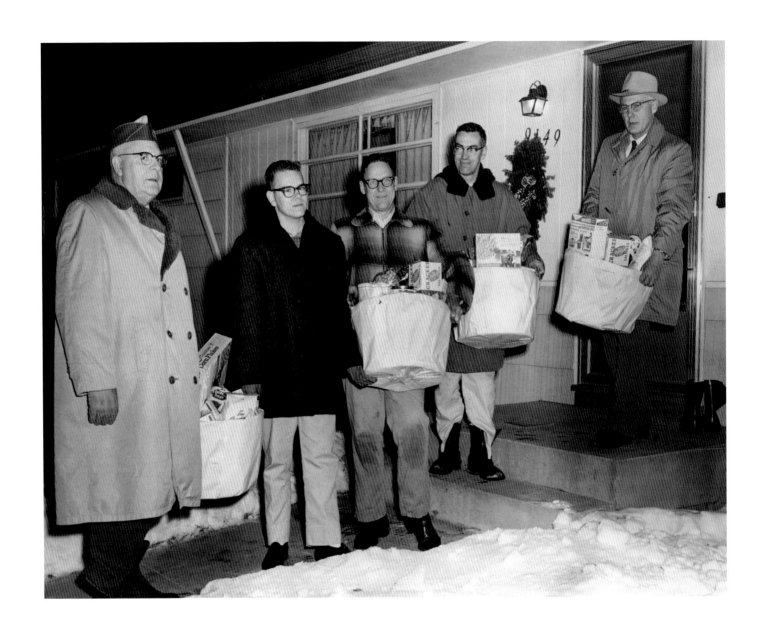

Distributing Lions Club Christmas baskets. 1961

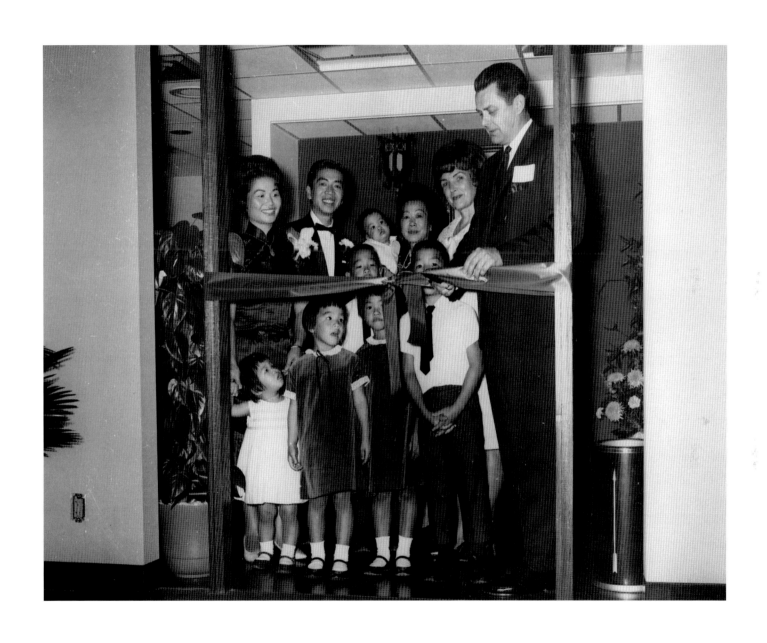

Ribbon cutting, David Fong's Chinese Restaurant. 1966

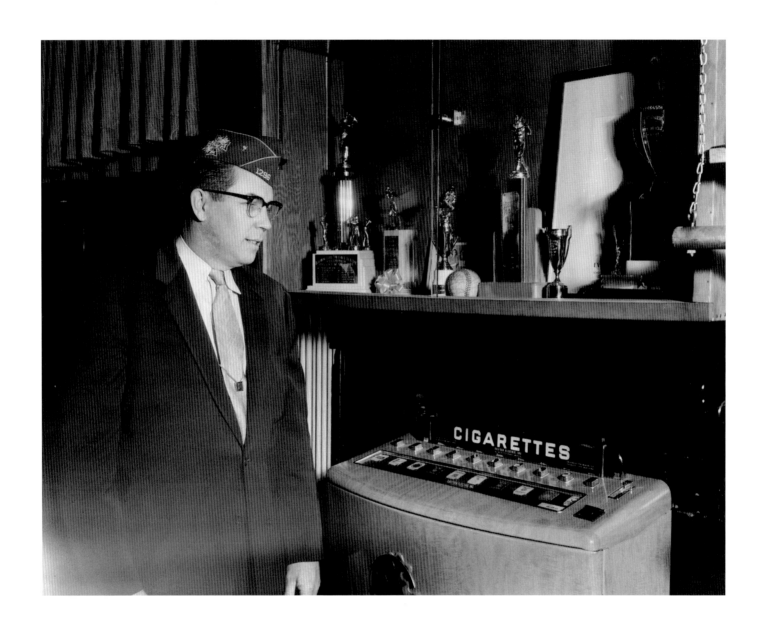

VFW Commander and trophies. 1956

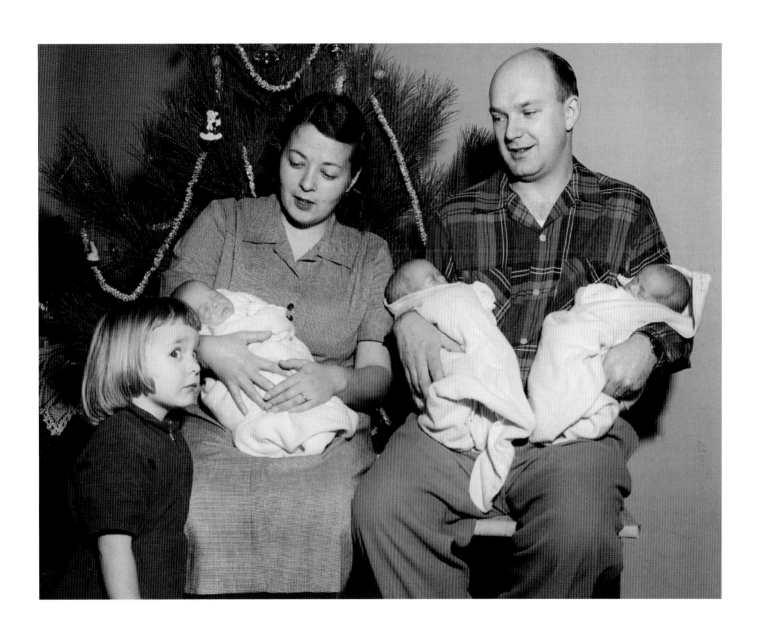

Mr. and Mrs. Howard Christianson with triplets and eight-year-old daughter. 1959

Preparations for a high school musical program. 1956

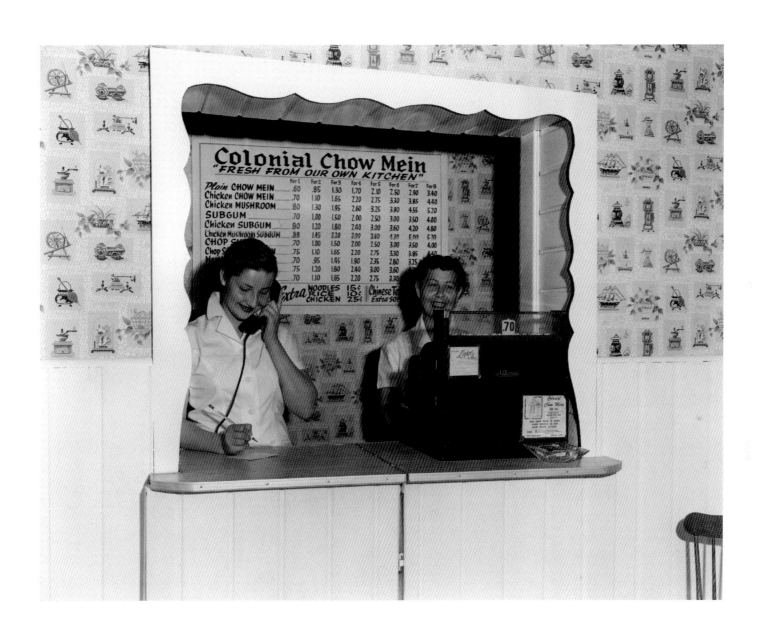

Fong's carryout Chinese, 98th Street and Lyndale Avenue. 1956

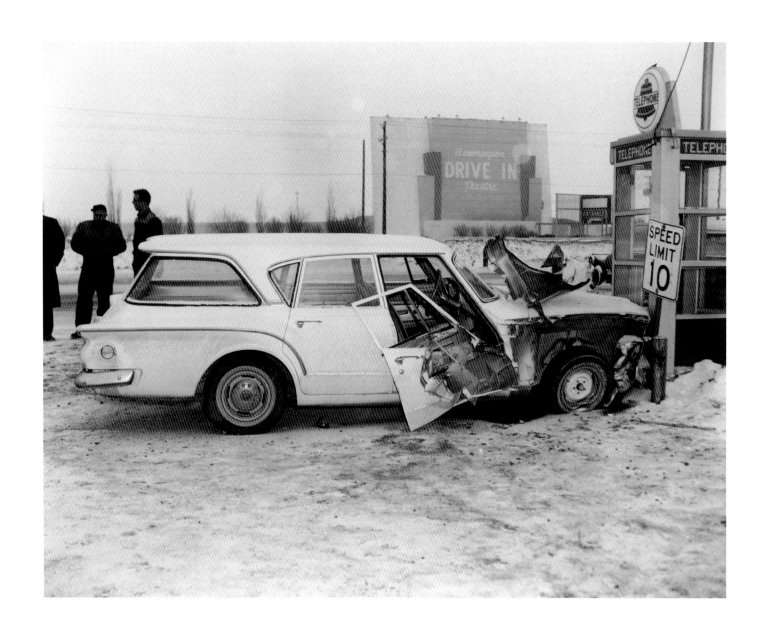

Accident. Phone booth. Drive-in movie theater. 1960

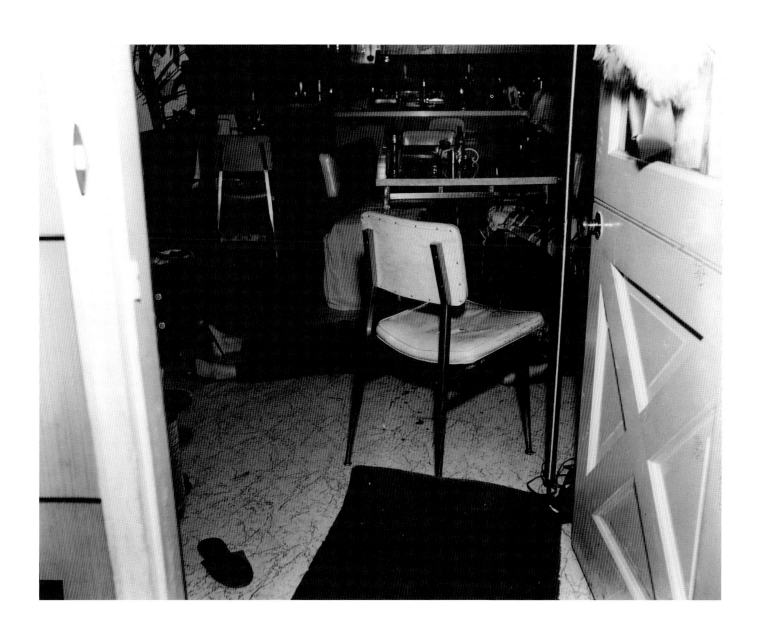

Murder-suicide [probably taken by Mike Norling]. 1962

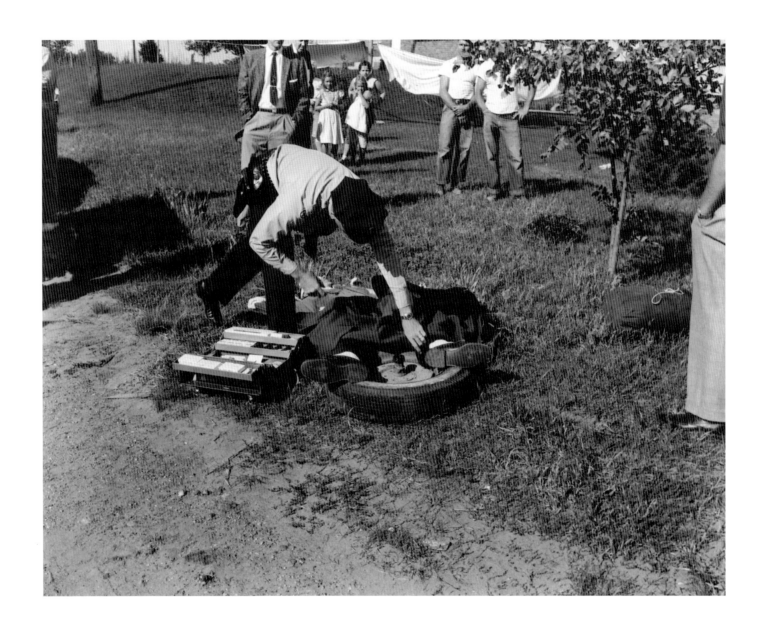

Fatal accident. 1956

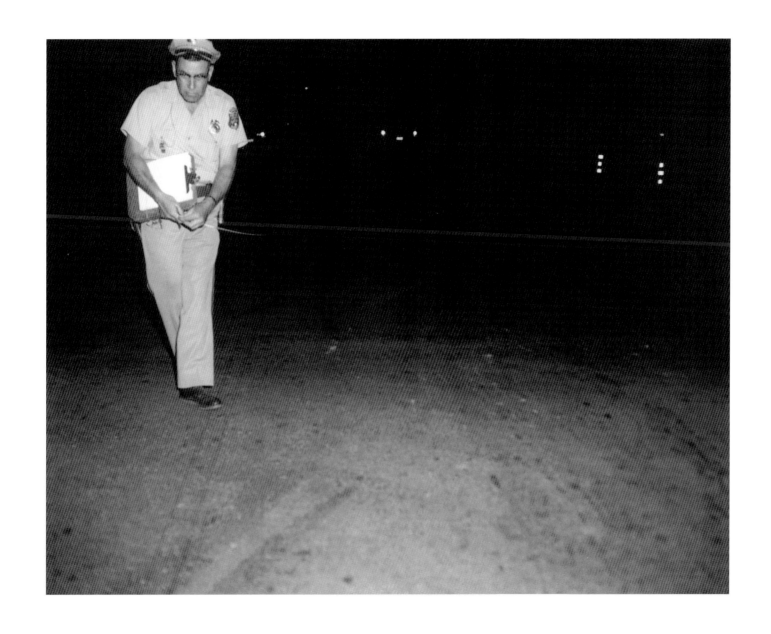

Accident scene investigation. 1960

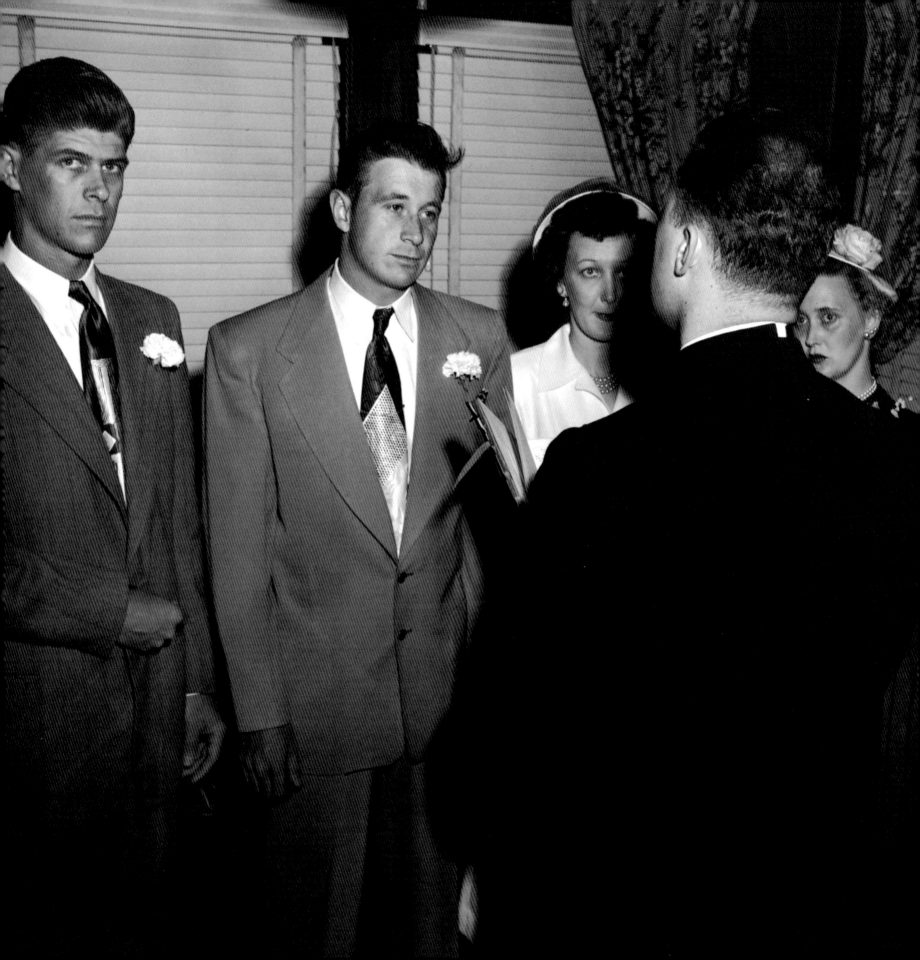

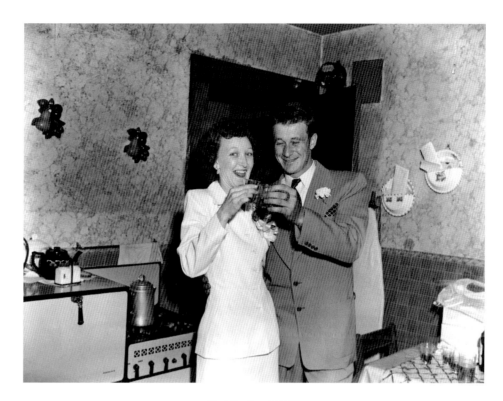

Wedding toast. 1948

Pat Buckley wedding. 1949

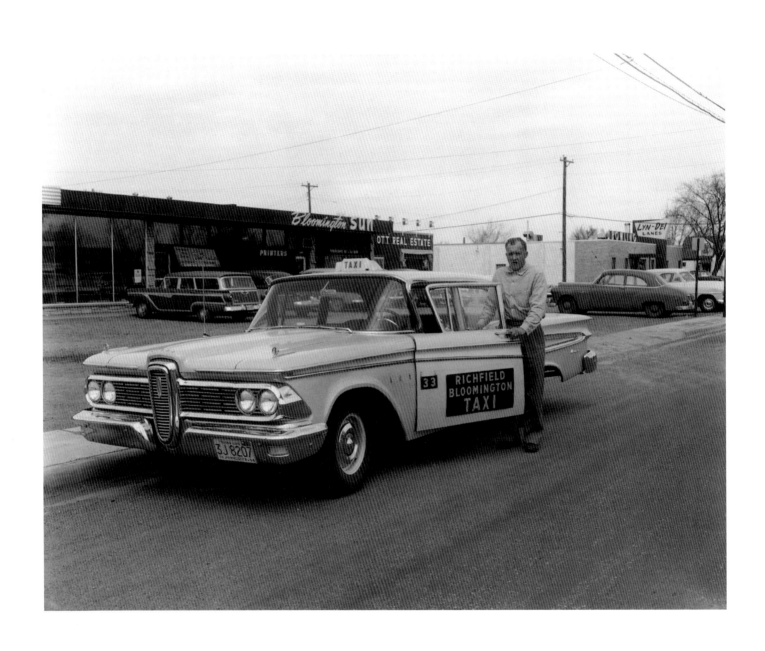

Bloomington-Richfield cab (Edsel), 94th Street and Lyndale Avenue. 1959

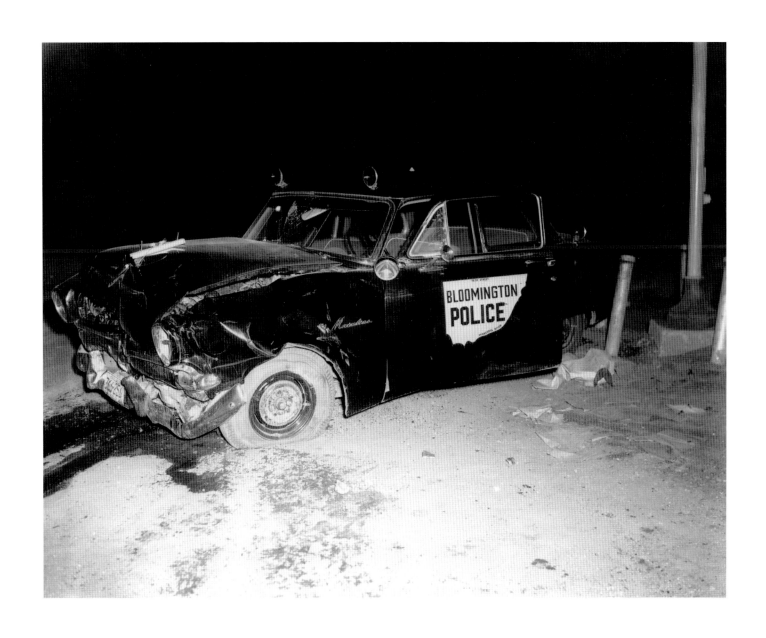

BPD squad car accident, circa 1951

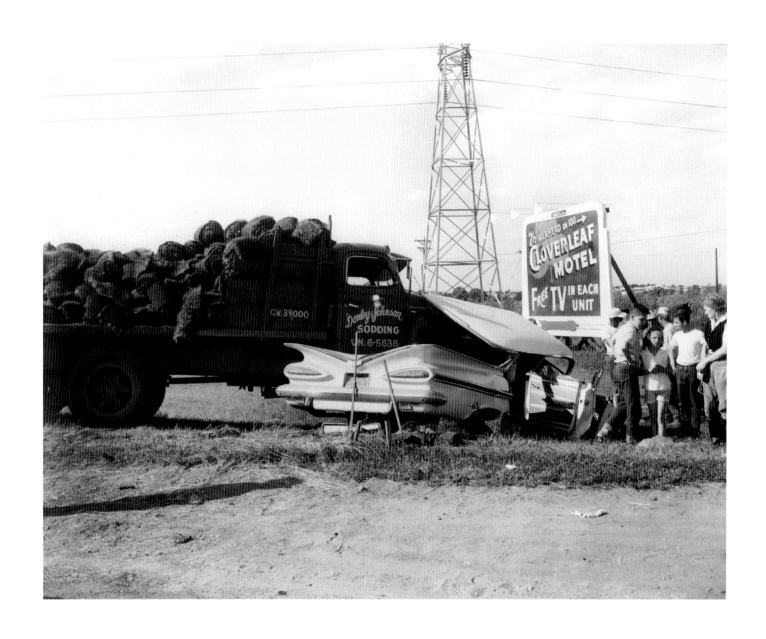

Sod truck accident. 1960

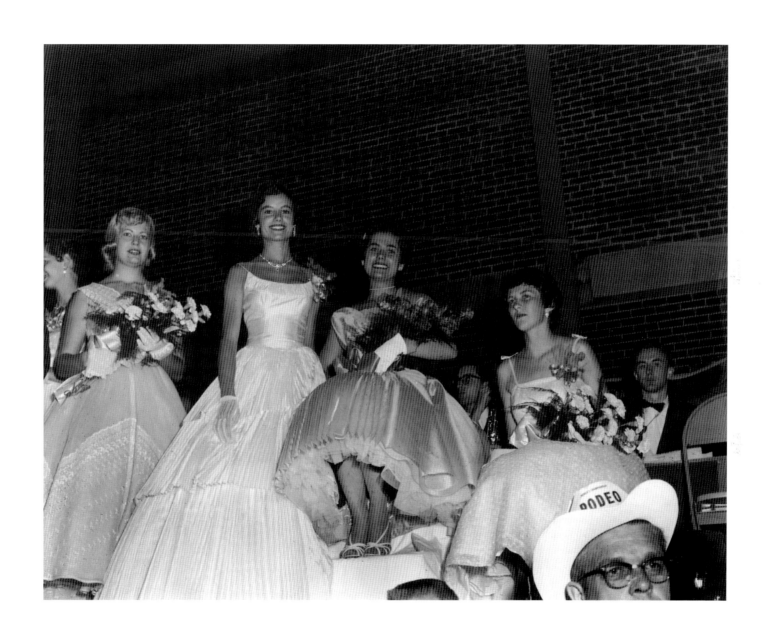

Lions Club rodeo queen contestants. 1956

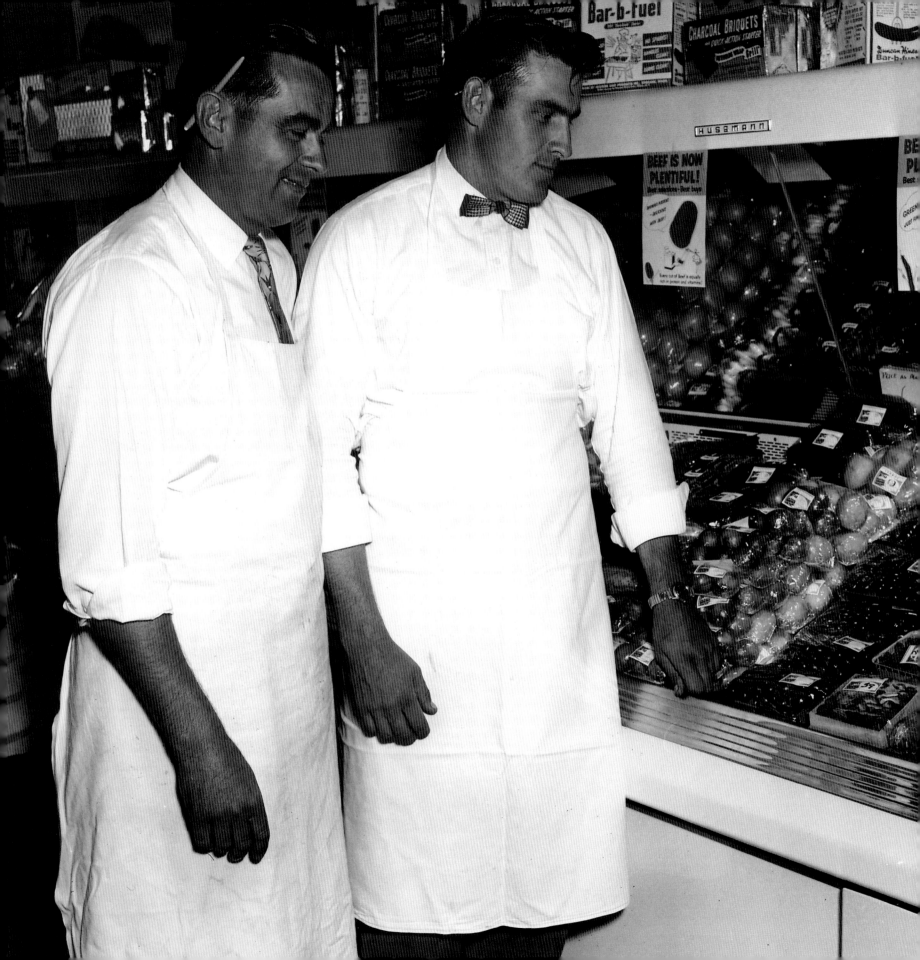

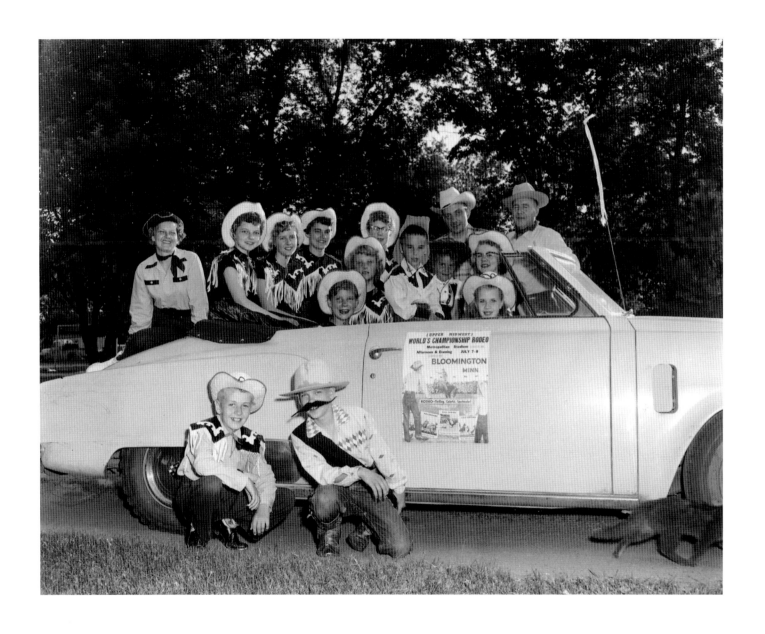

Rodeo queen contestants and kids. 1956

FACING PAGE: Mike and Jeff Kakach, Super Valu owners. 1956

Valley View dedication. 1958

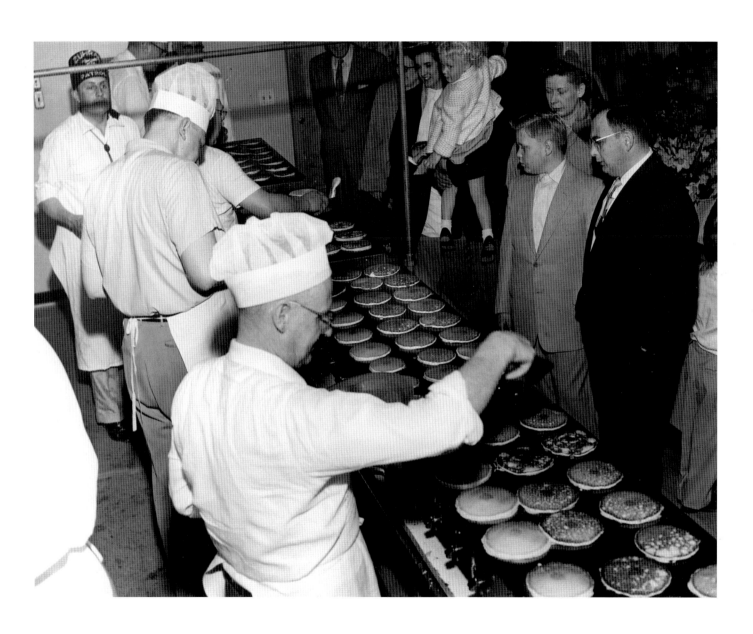

Shrine Club pancake breakfast. 1957

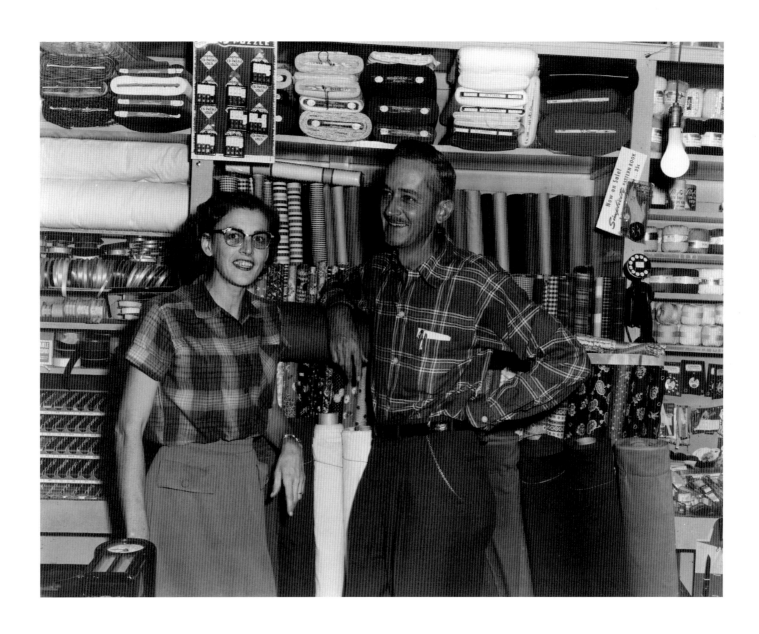

Owner and manager of Oxboro Variety Store, 98th Street and Lyndale Avenue. 1956

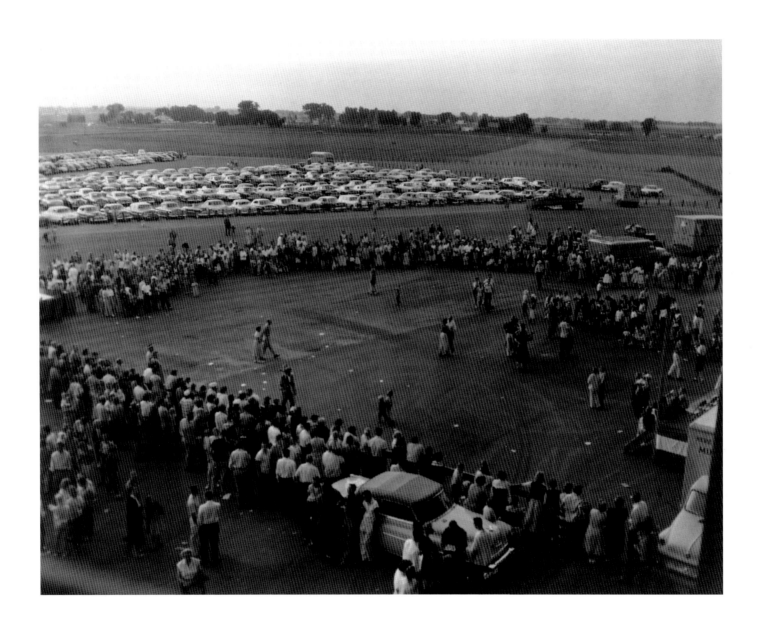

Lions Club rodeo dance. 1956

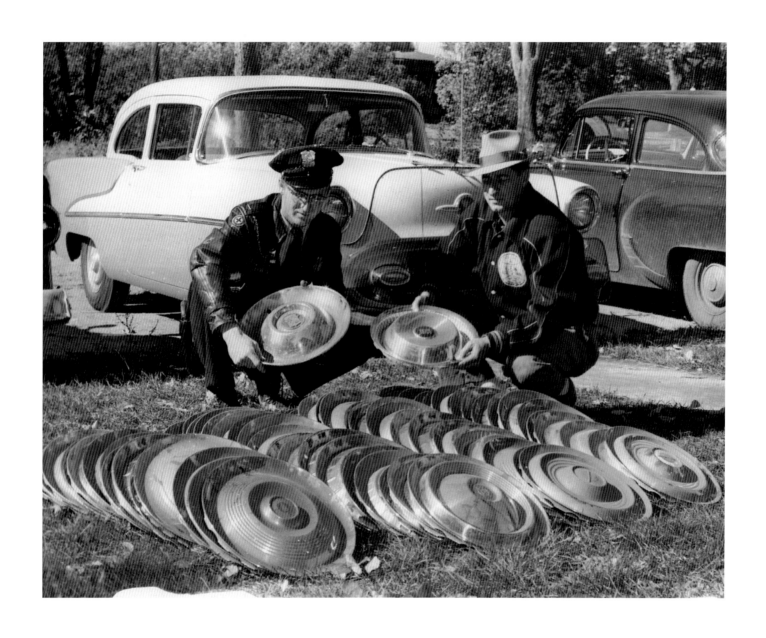

BPD officers Paul Block and Virgil Pahl with recovered hubcaps. 1955

FACING PAGE: BPD officers with new speed detector. 1957

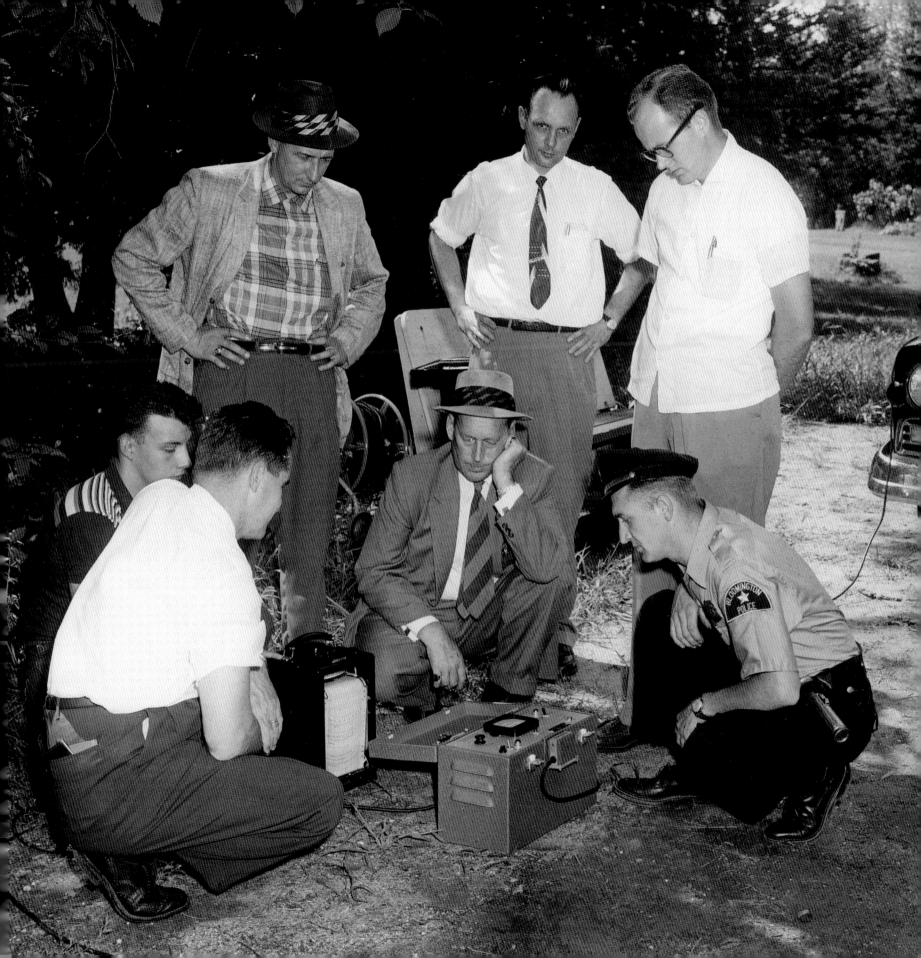

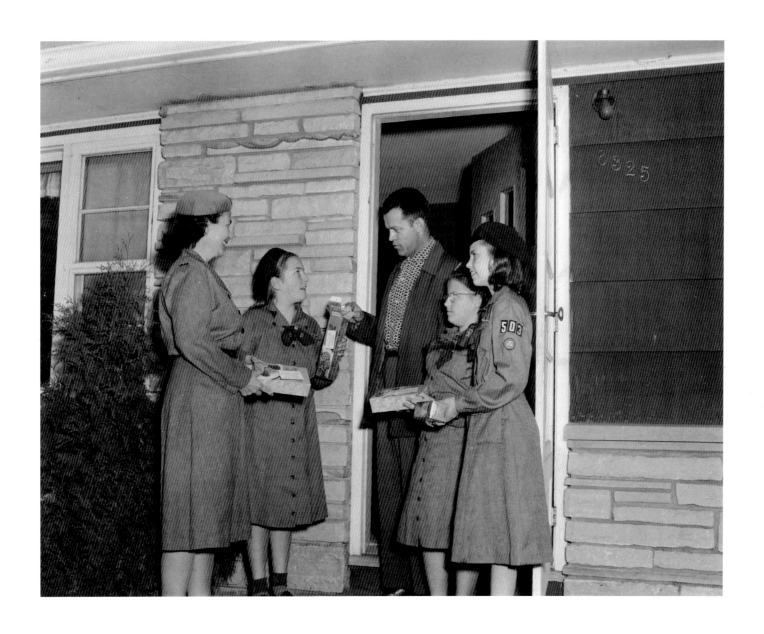

Selling Girl Scout cookies. 1957

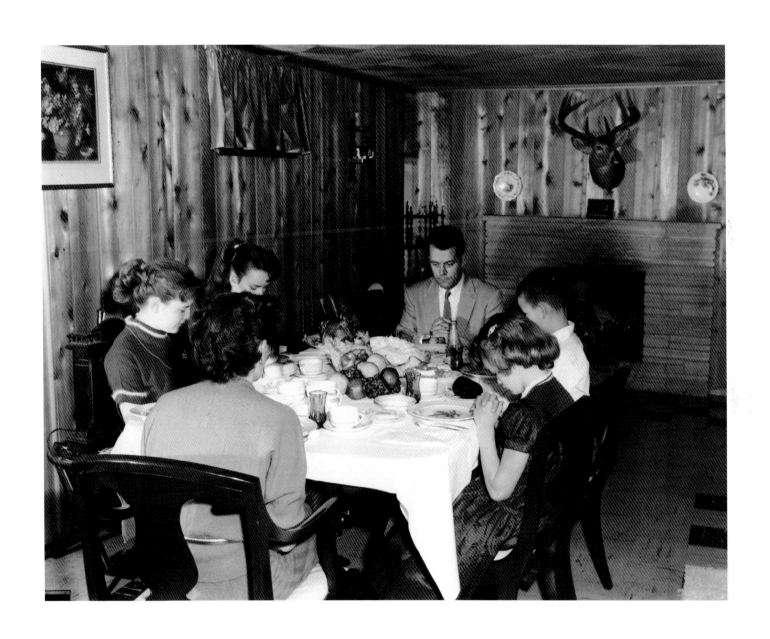

Mayor Gordon Miklethun with family at Thanksgiving. 1956

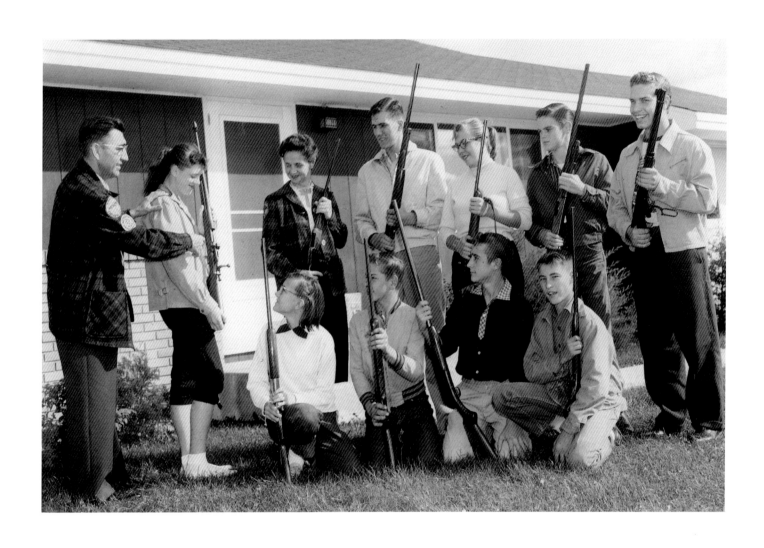

Willis Wariner gun-training class. 1957

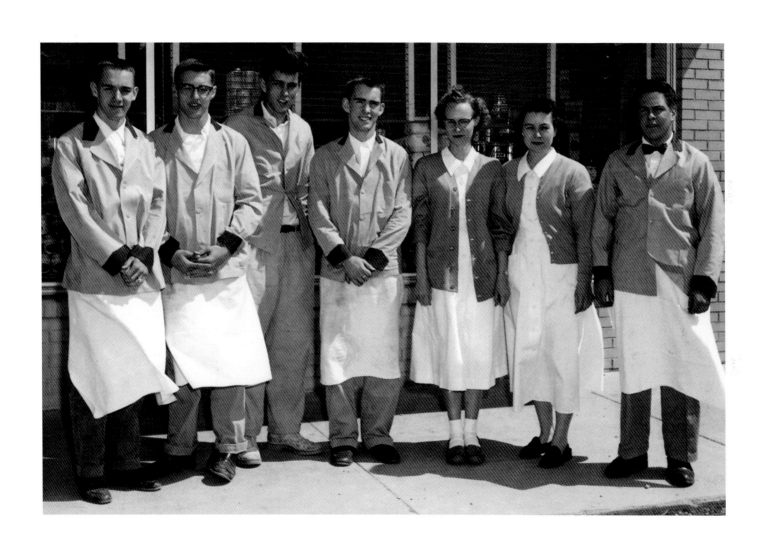

Super Valu employees. 1956

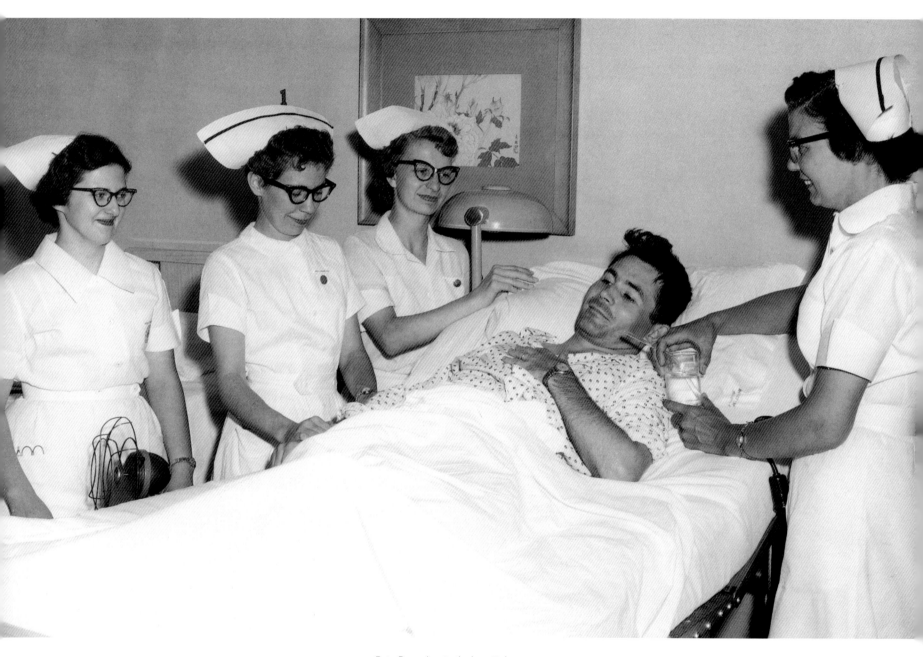

Pete Donaghue in the hospital. 1957

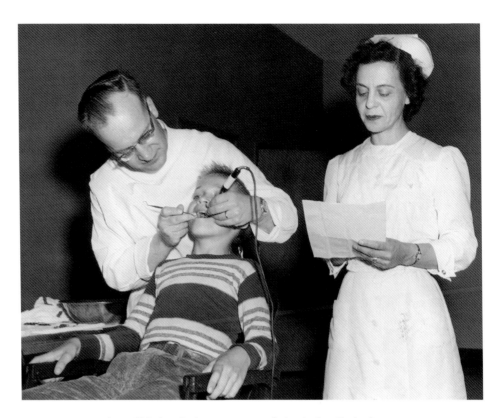

Lions Club dental education program [taken by June Norling]. 1955

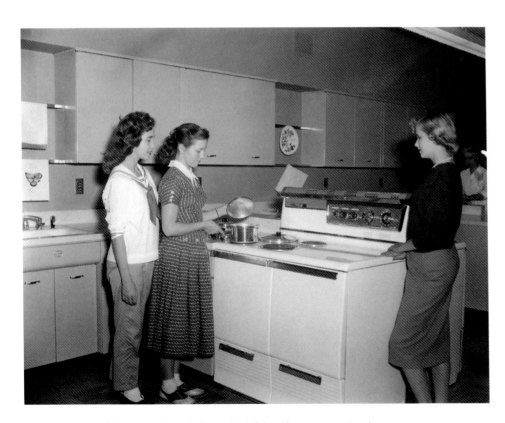

Bloomington Lincoln Senior High School home economics class. 1957

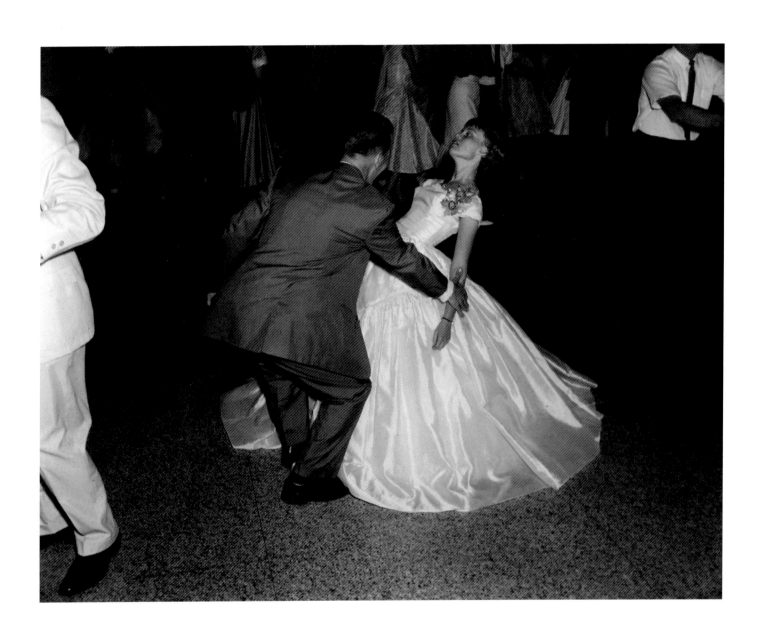

Lions Club Ball. 1959

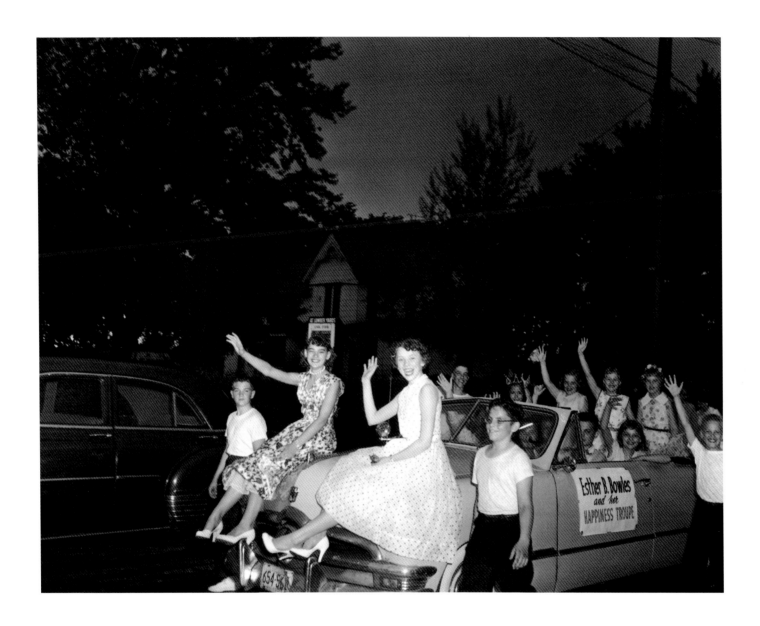

Esther Bowles Dance Studio float, American Legion Convention parade. 1954

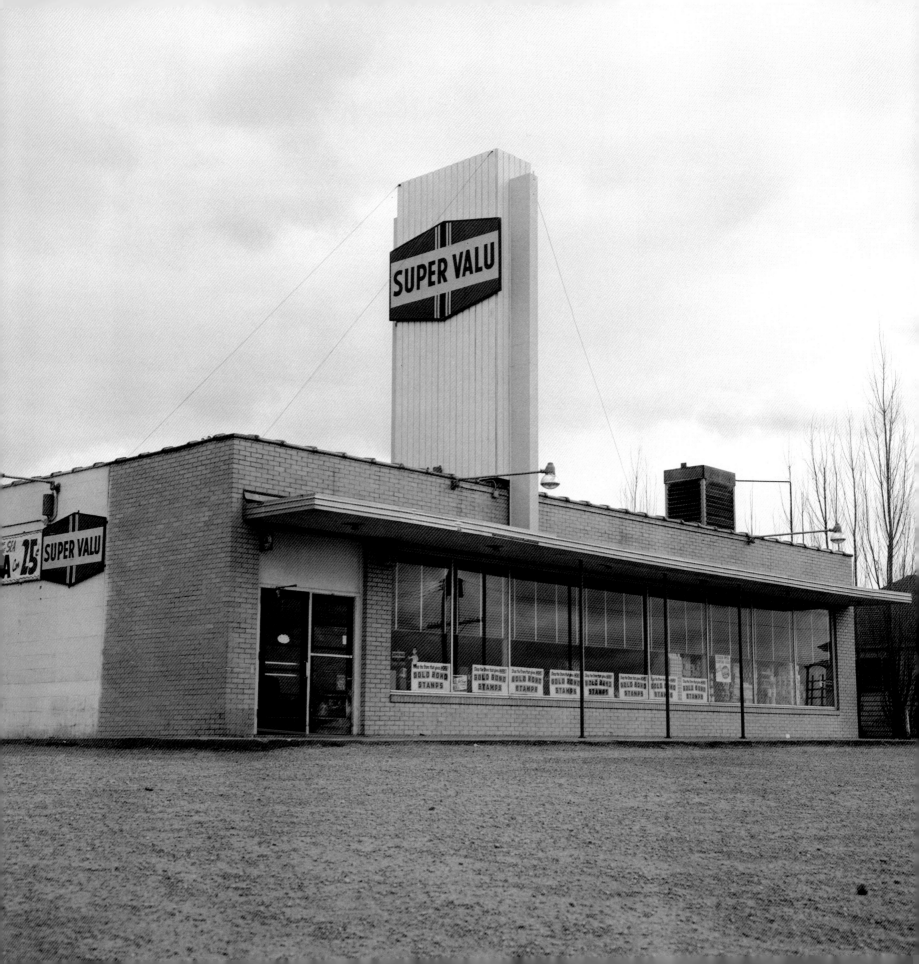

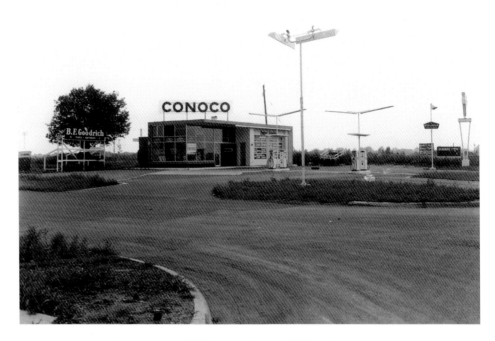

Conoco station, Old Shakopee Road and Aldrich Avenue. 1959

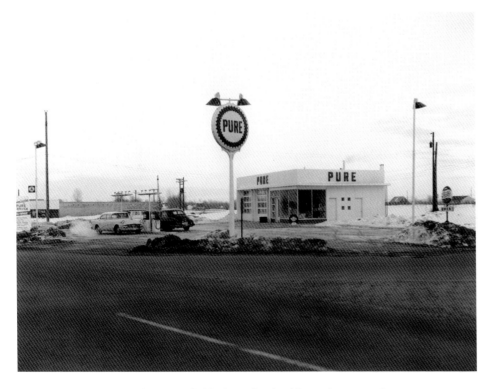

Pure Oil station, Old Shakopee Road and France Avenue. 1956

FACING PAGE: Super Valu, circa 1955

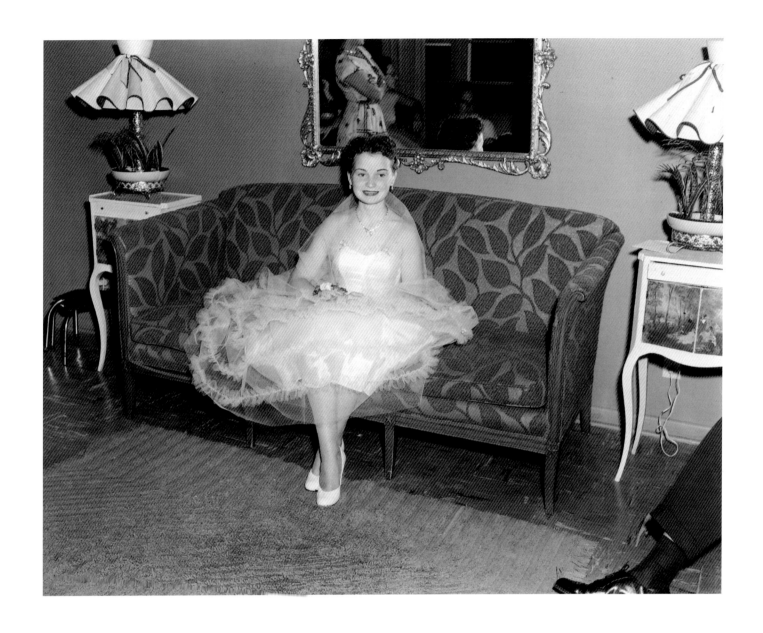

Donna Jewett. 1955

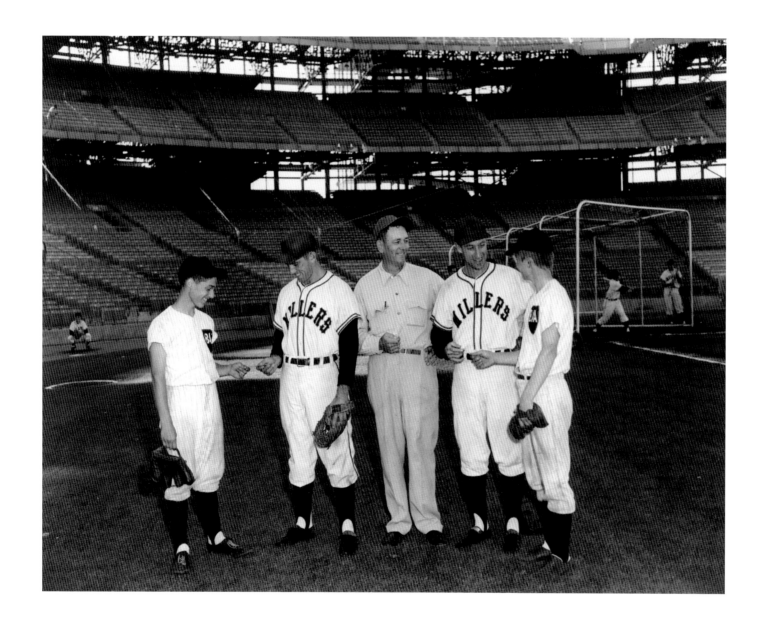

Minneapolis Millers at Metropolitan Stadium. 1957

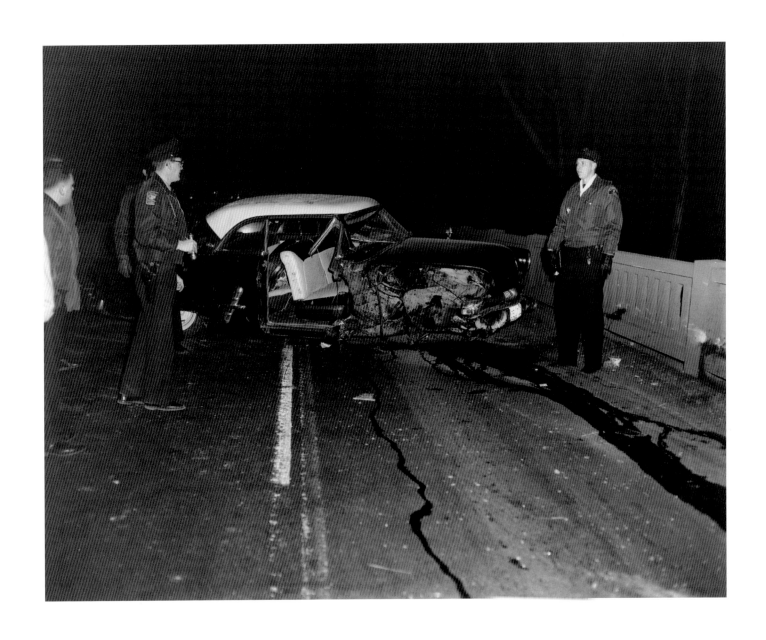

Lyndale Avenue and Minnesota River Bridge. 1959

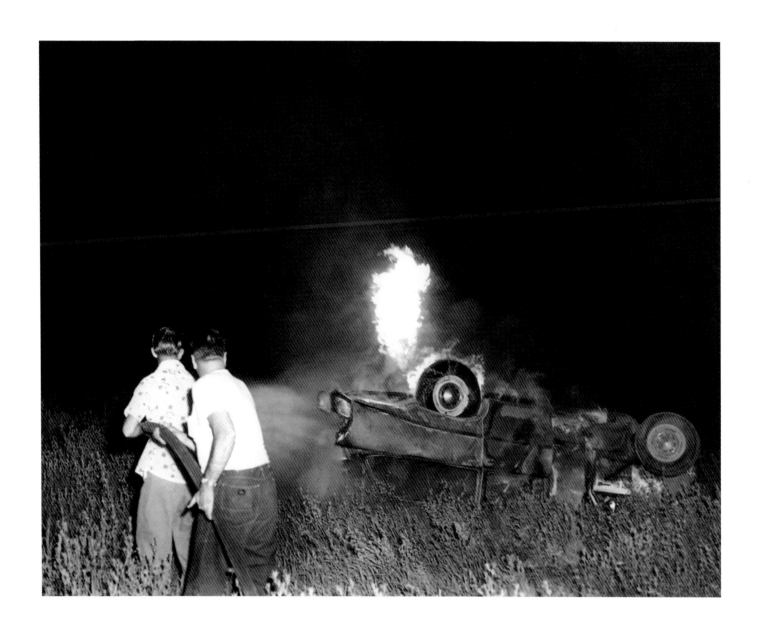

Accident, 102nd Street. 1957

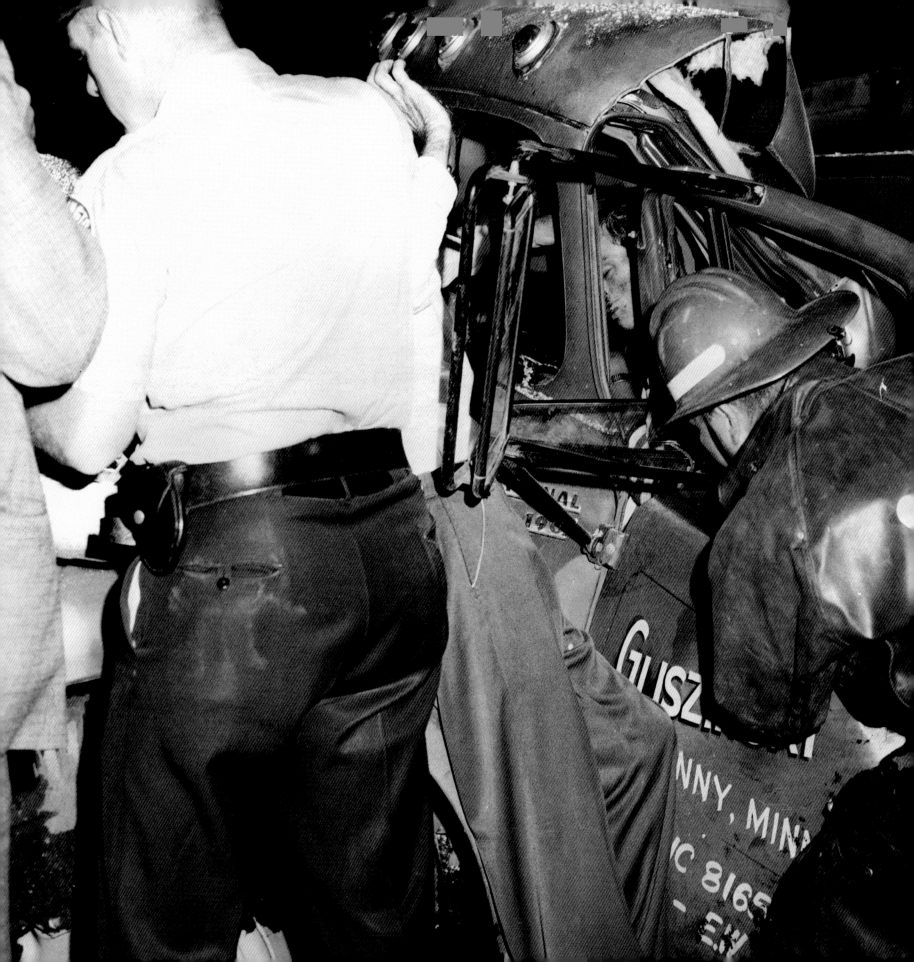

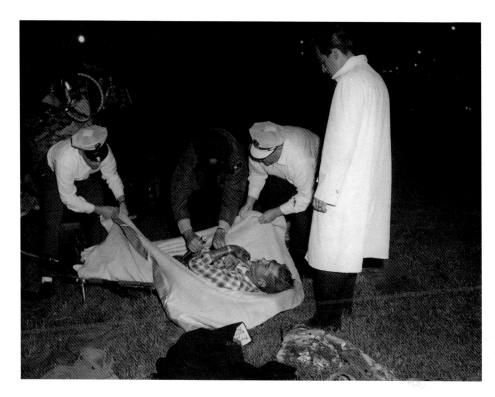

Fatal accident, Interstate Highway 494 and 17th Avenue. 1961

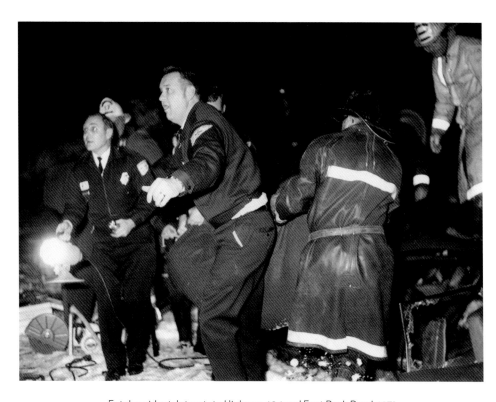

Fatal accident, Interstate Highway 494 and East Bush Road. 1971

FACING PAGE: Fatal accident, Highways 13 and 101. 1962

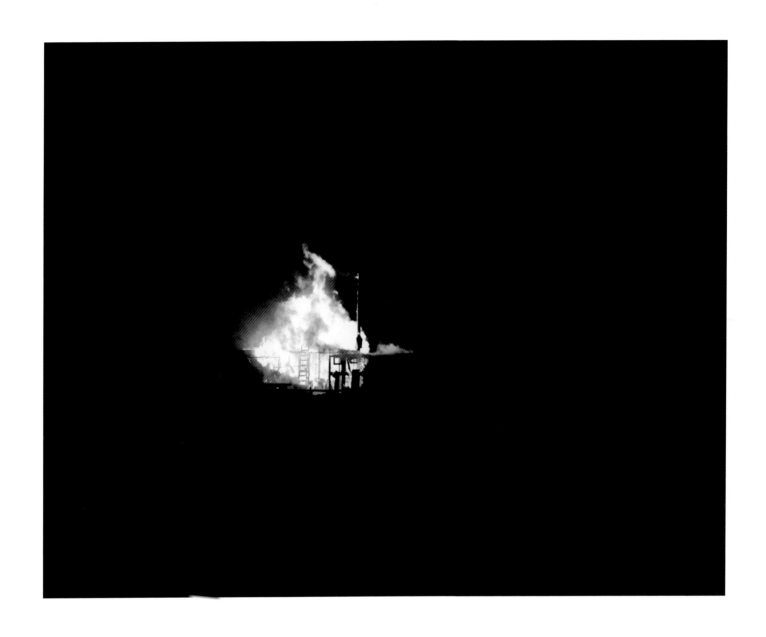

Metropolitan Stadium toolshed fire. 1956

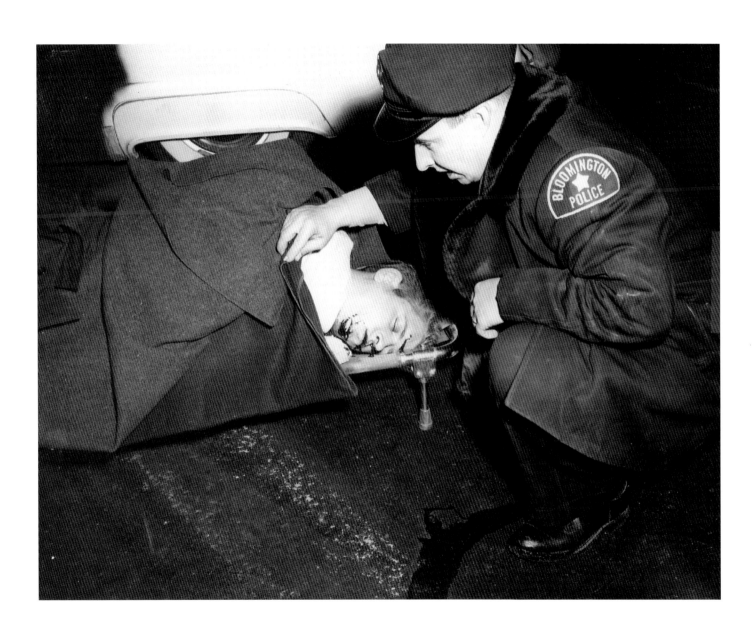

Minnesota River Bridge accident, two fatalities. 1960

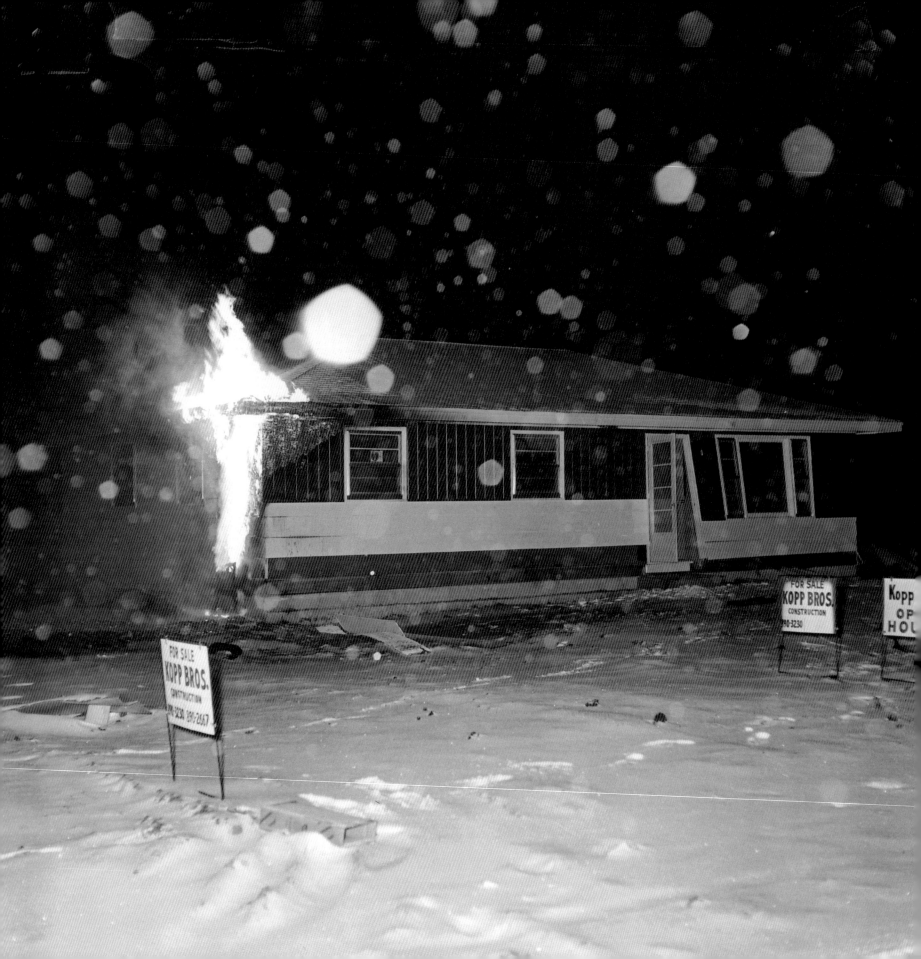

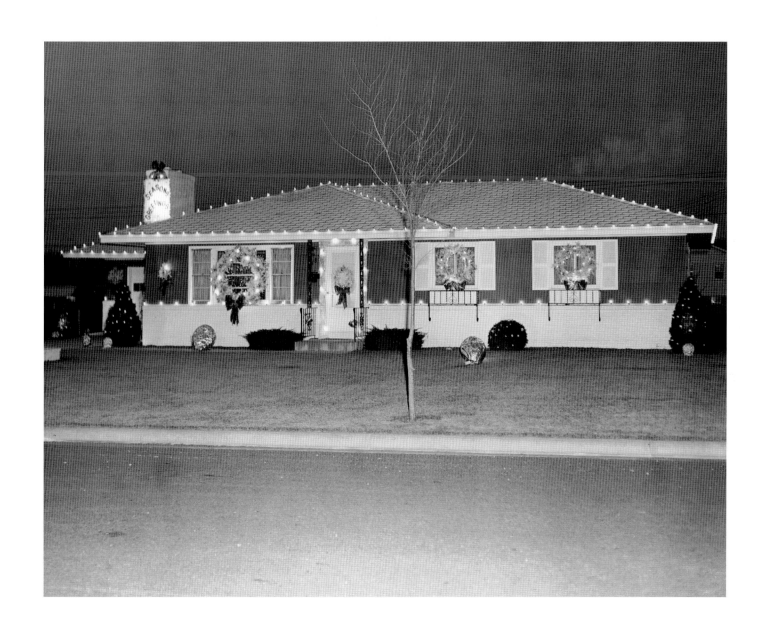

Christmas lights contest winner. 1960

FACING PAGE: Model home explosion. 1965

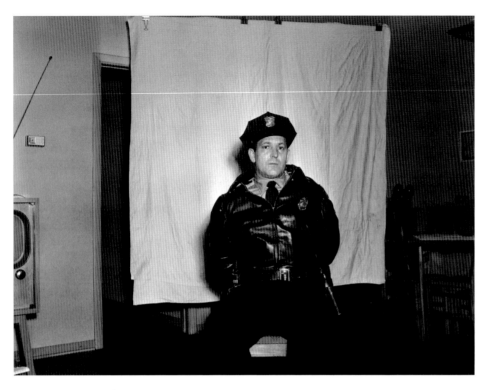

BPD officer Warren Shaper. 1955

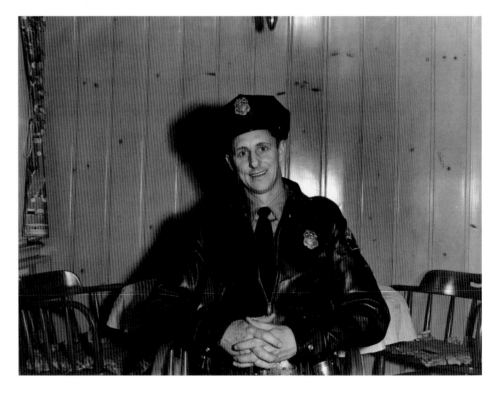

New BPD officer Everett Engstrom. 1957

FACING PAGE: BPD officer Jerry Ruehle rescuing trapped dog. 1956

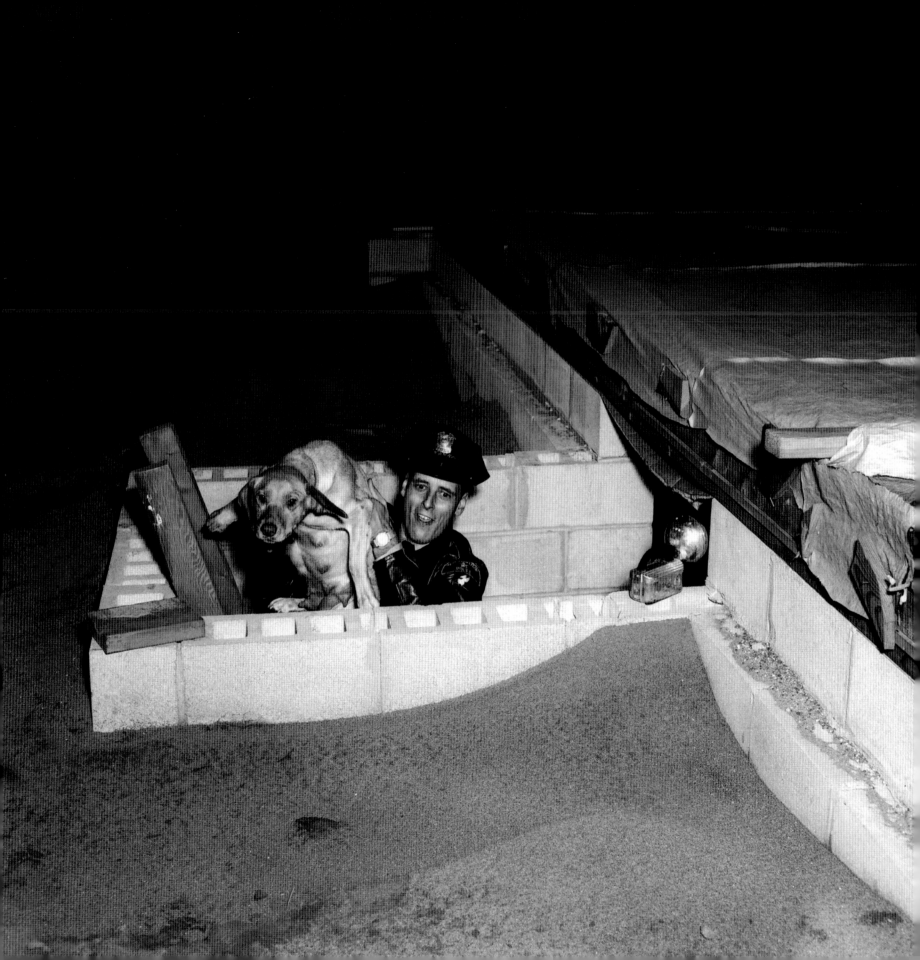

Mayor Herman Kossow. 1956

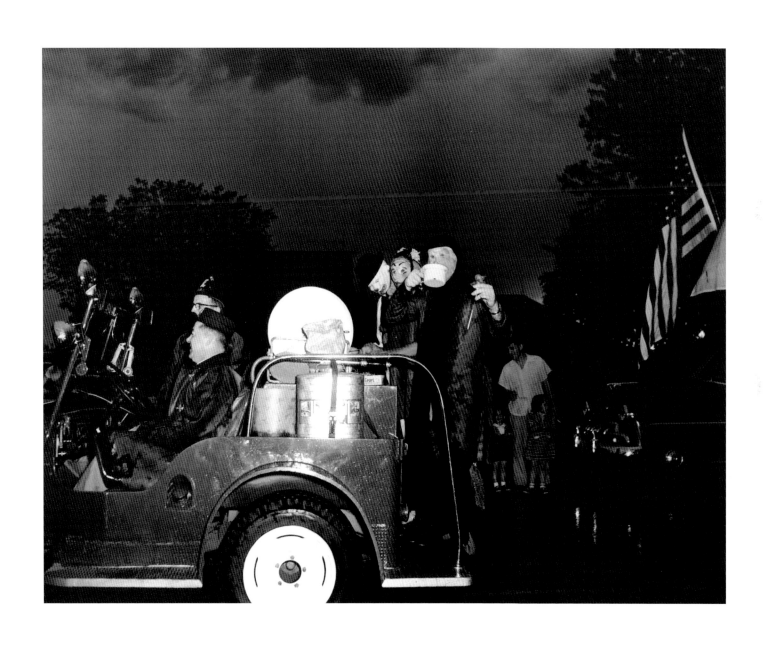

BFD truck in American Legion Convention parade. 1954

Larry and Arnie Pahl, Bloomington Linoleum and Tile. 1956

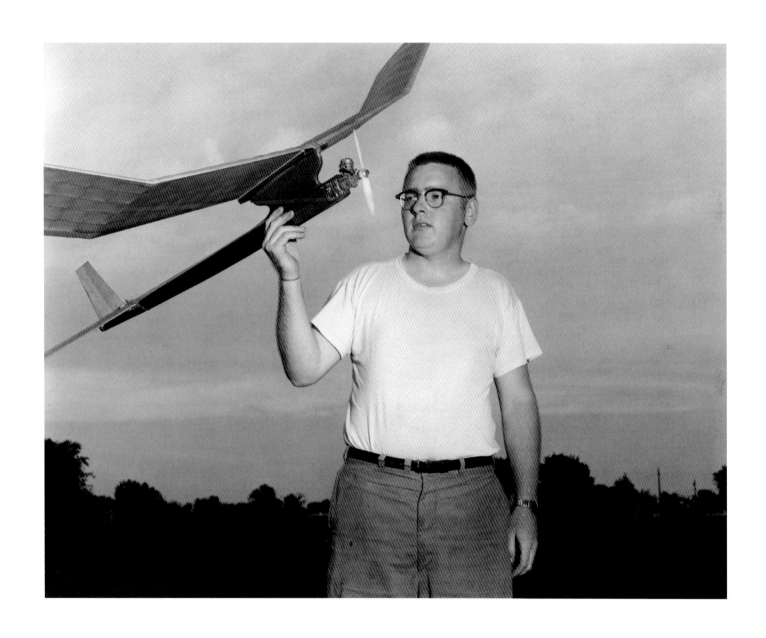

Gary Westlund and model airplane. 1959

Dance recital, circa 1956

David Fong. 1959

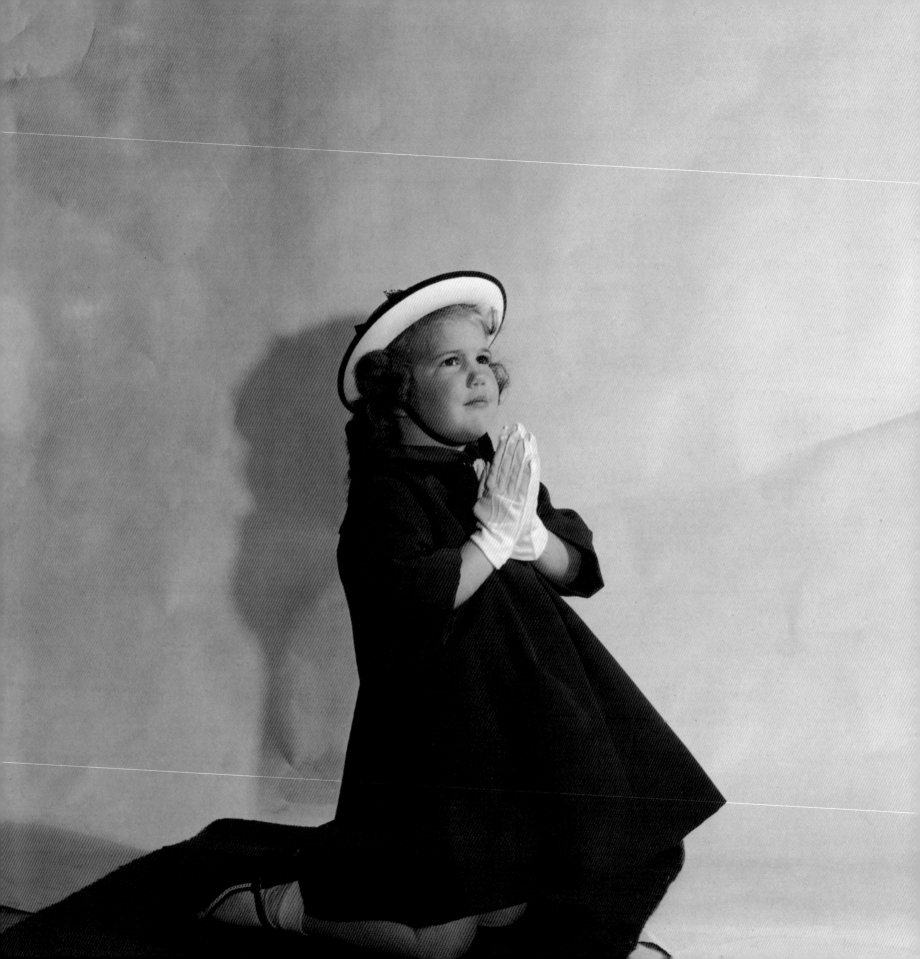

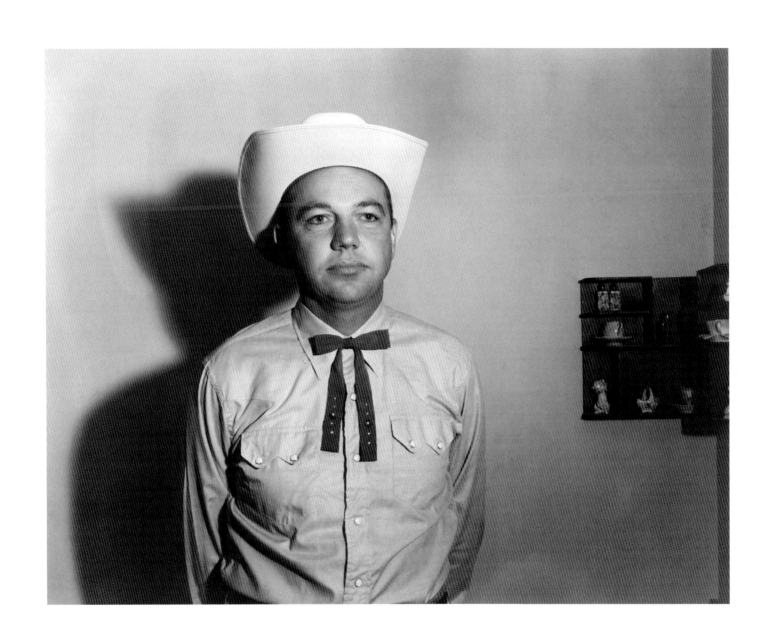

Lions Club rodeo. Marv Anderson. 1957

FACING PAGE: Easter portrait. 1957

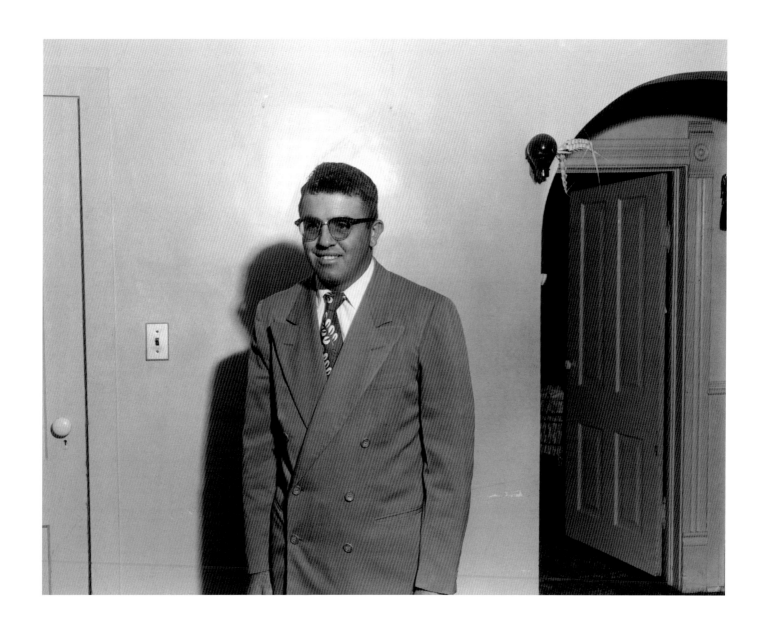

Dennis Bungert. 1956

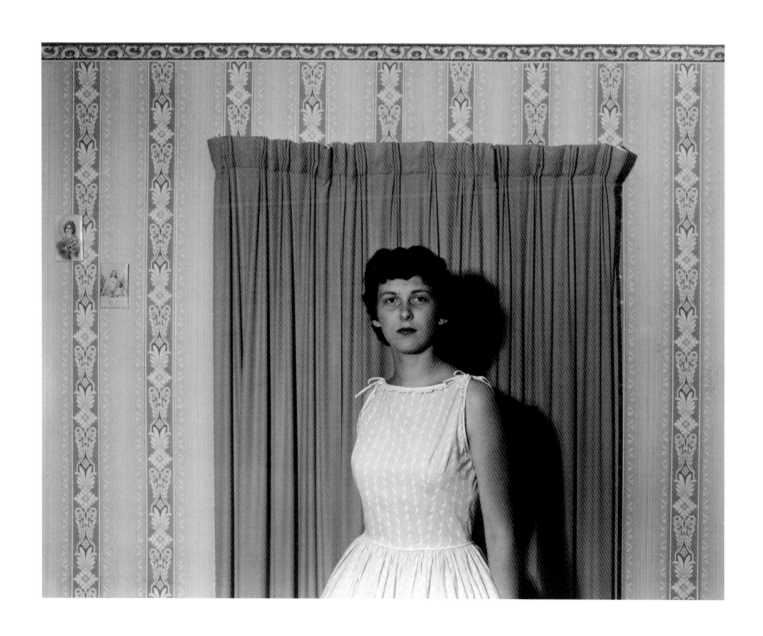

Phyllis Kramer, Lions Club rodeo queen candidate. 1956

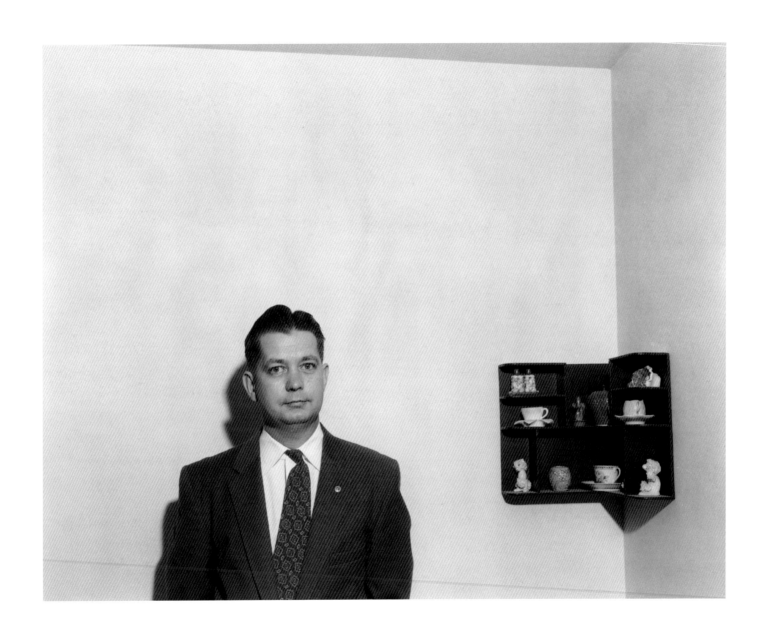

Lloyd Docken. 1956

Lions Club rodeo portrait. 1957

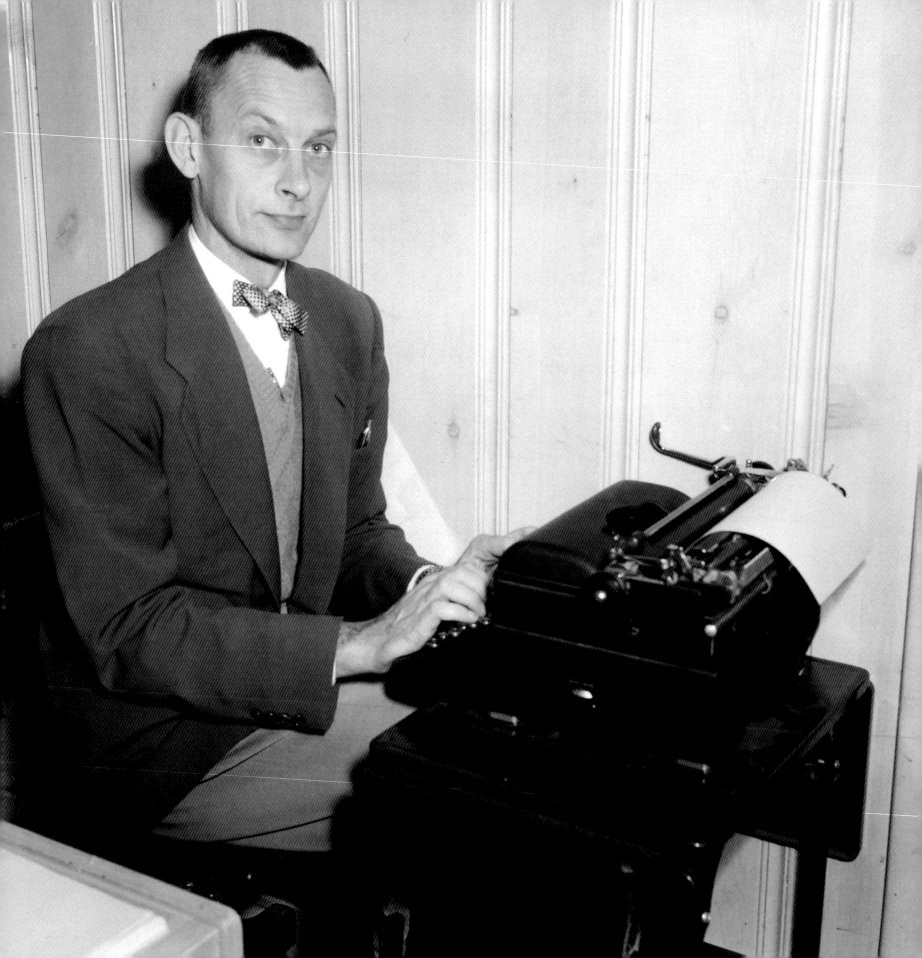

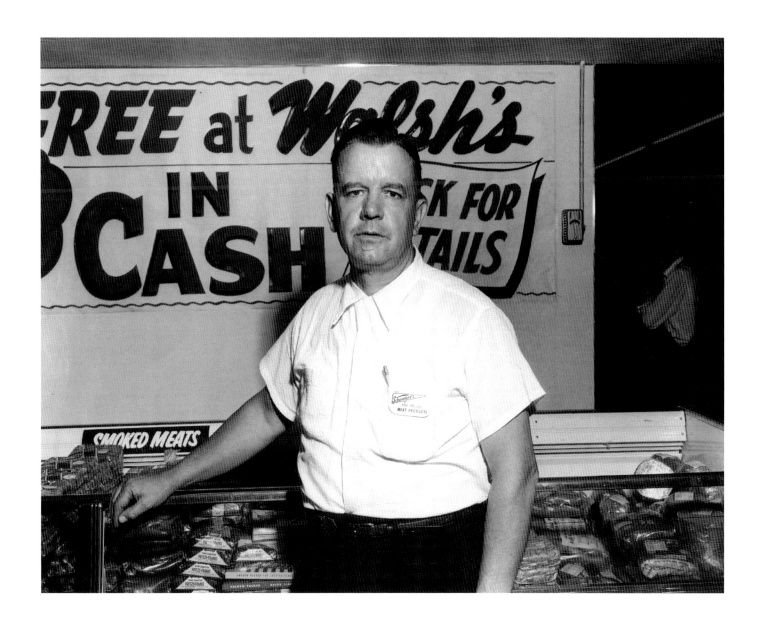

Larry Walsh, owner of Walsh's Market. 1956

FACING PAGE: Jim Logan, *Bloomington Sun* columnist. 1956

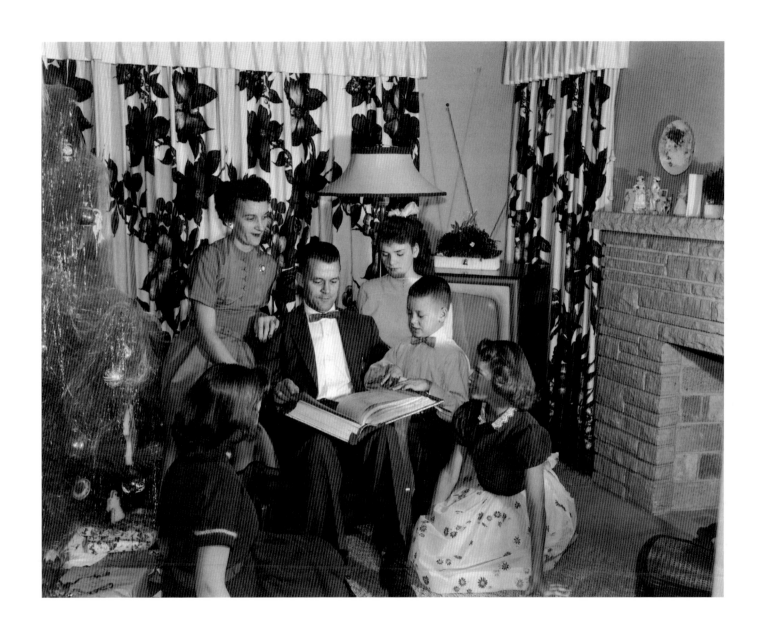

Gordon Miklethun family. 1956

School pageant, circa 1955

Fred Gerard's retirement party (Fred with Alec Ellis). 1955

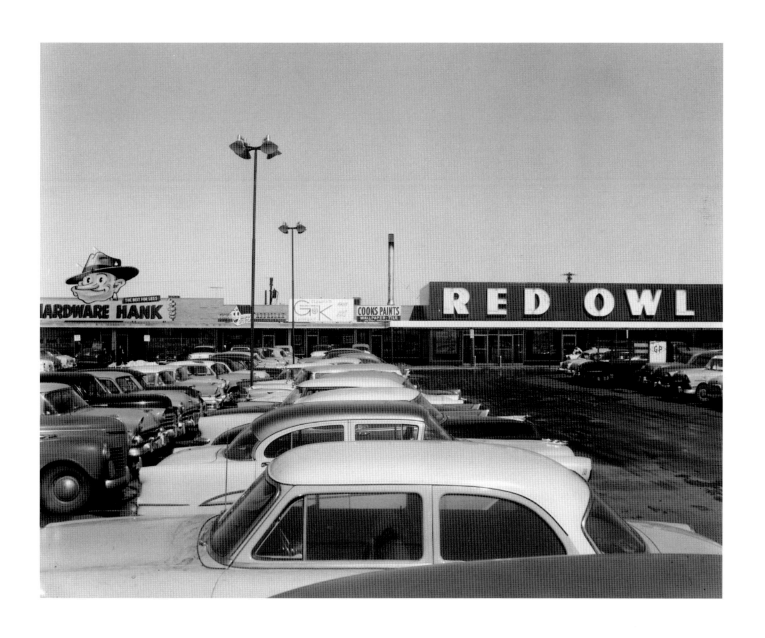

Clover Shopping Center, 98th Street. 1957

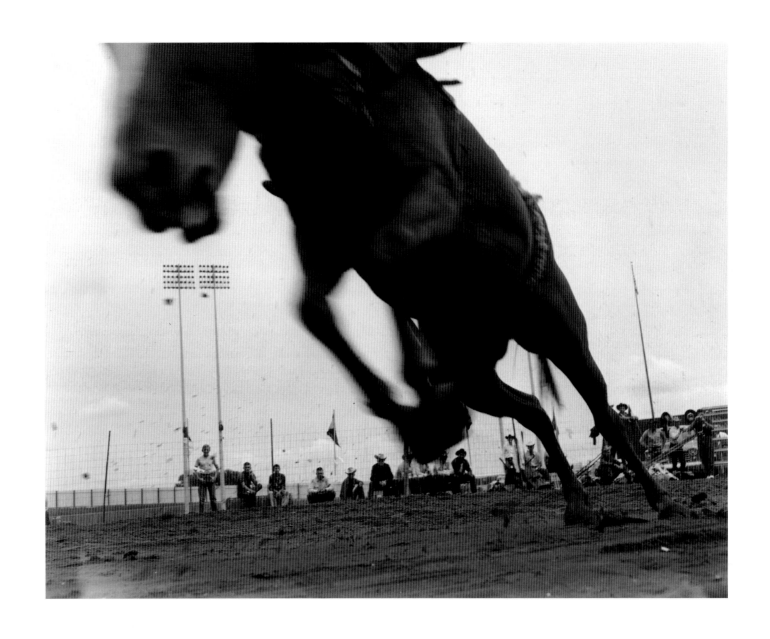

Bucking horse, Lions Club rodeo. 1956

FACING PAGE: Lions Club rodeo portrait. 1956

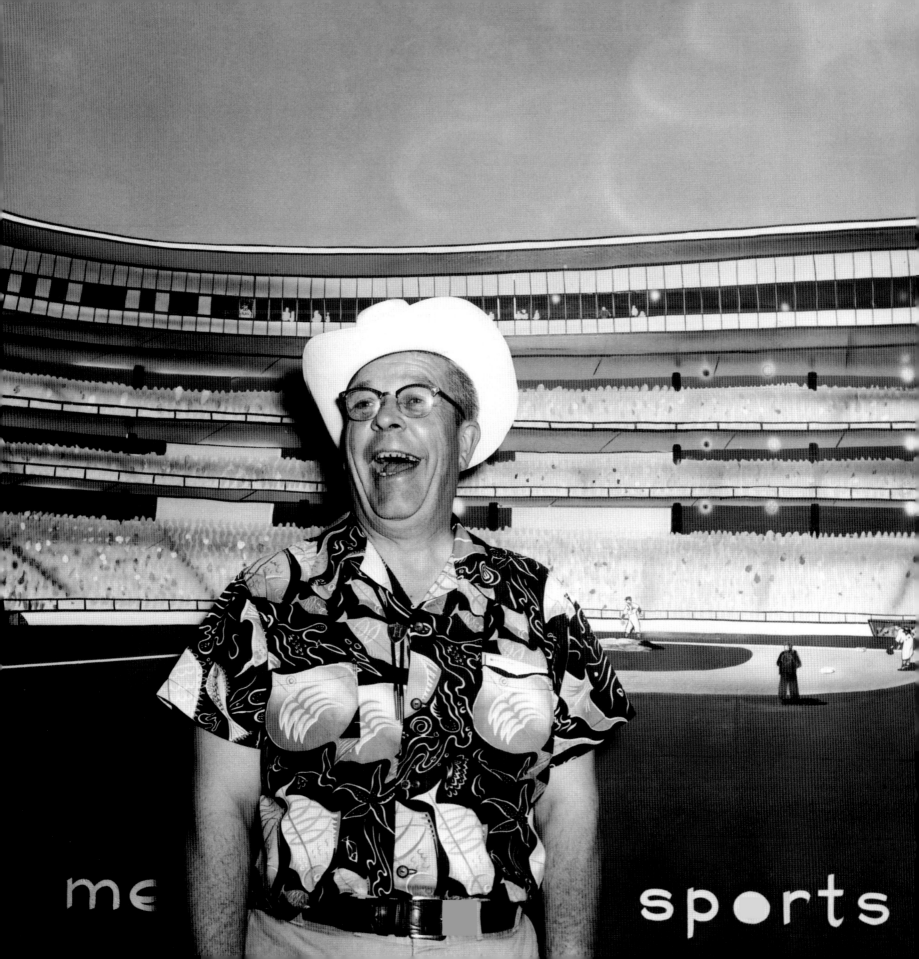

Collins Shows carnival. 1961

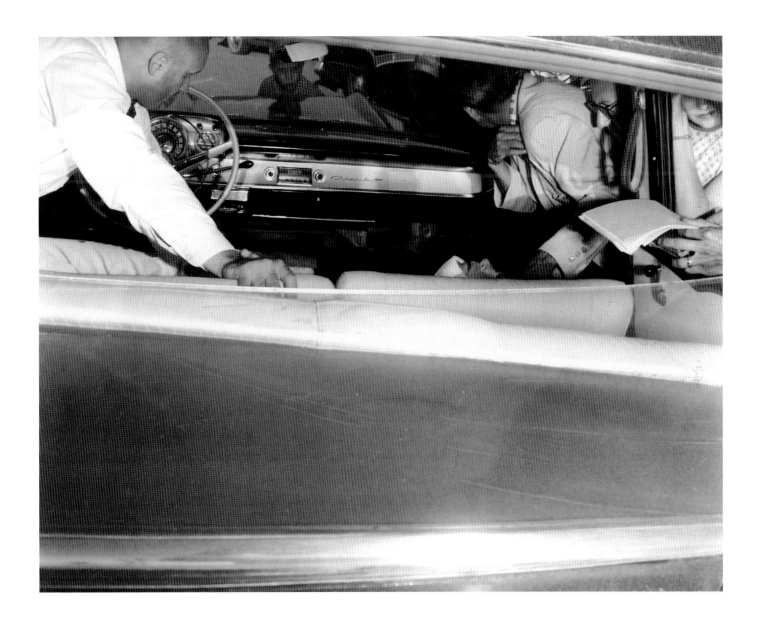

Gawkers at accident scene. 1956

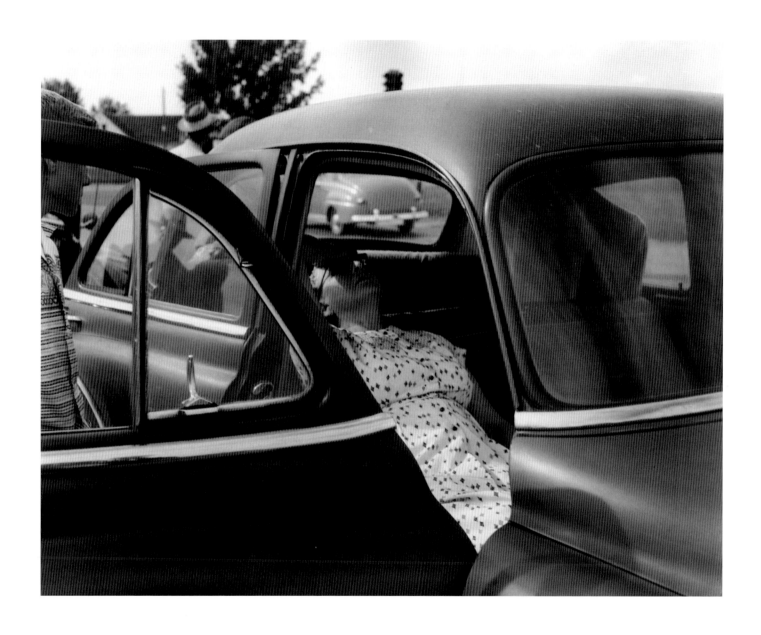

Accident victim with onlooker. 1954

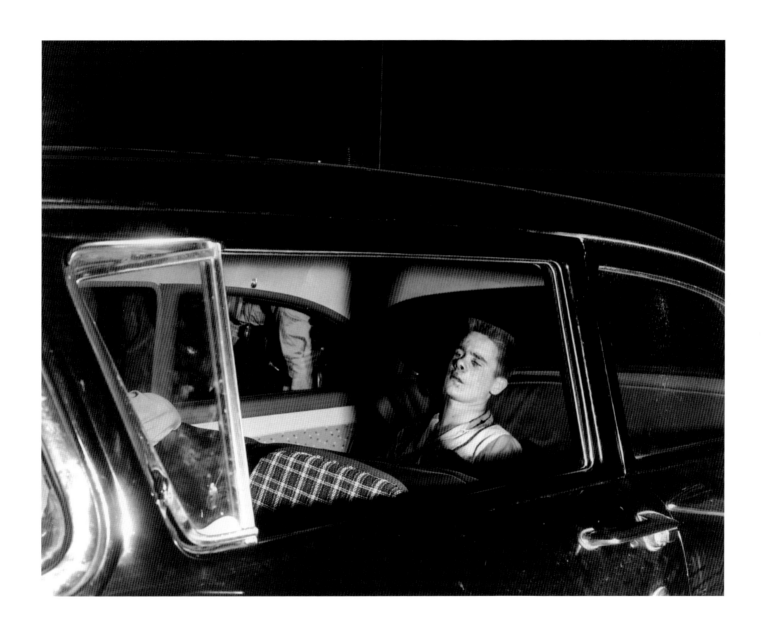

Accident, 102nd Street. 1957

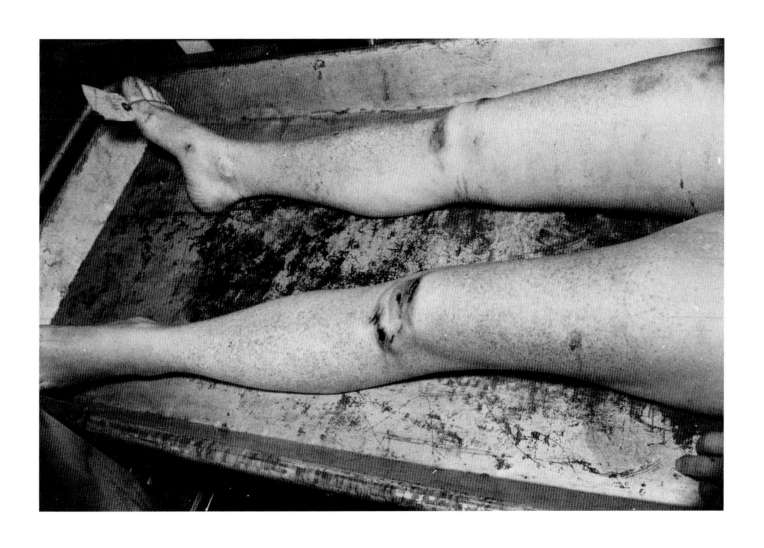

Autopsy photo. Undated

FACING PAGE: Owner, Hardware Hank store, 98th Street and Lyndale Avenue. 1957

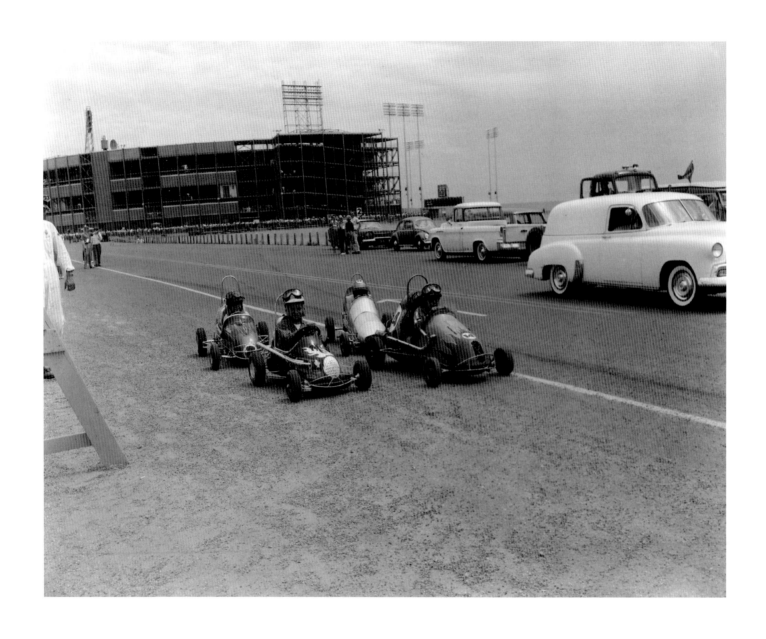

Sports car race, Metropolitan Stadium. 1957

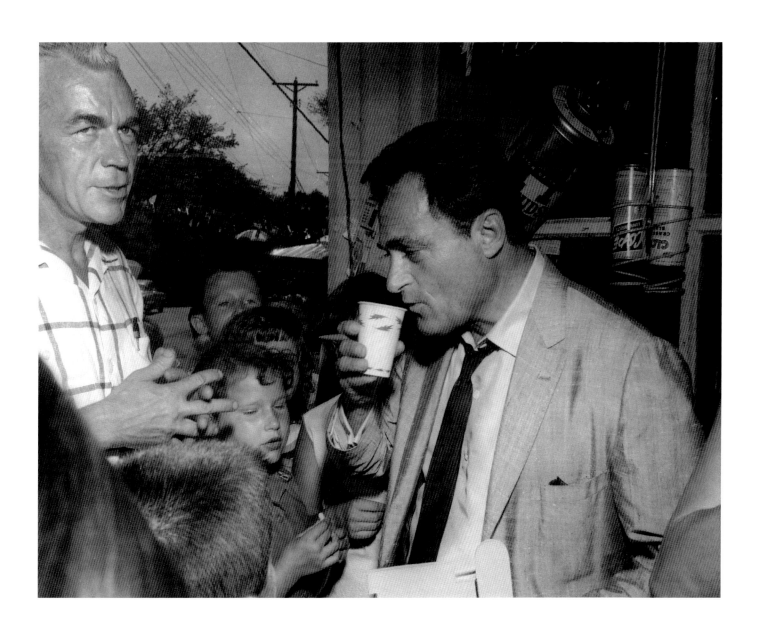

Mike Todd, on the porch of his father's old general store. 1957

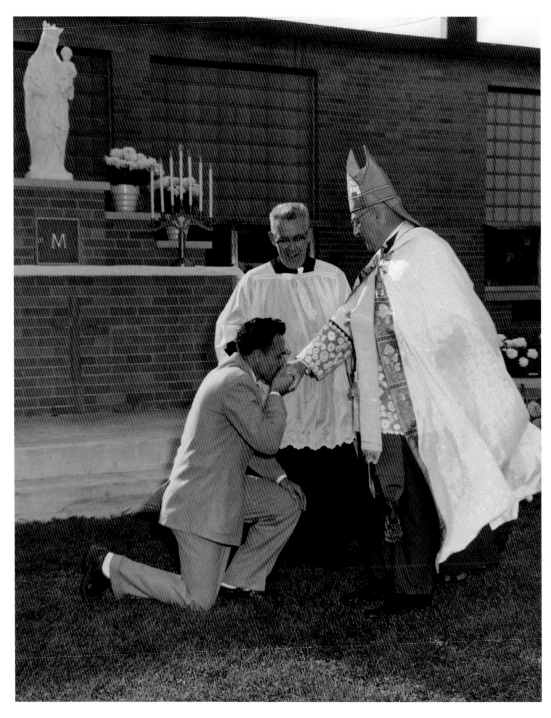

Dedication of the Nativity of Mary Shrine, with bishop. 1957

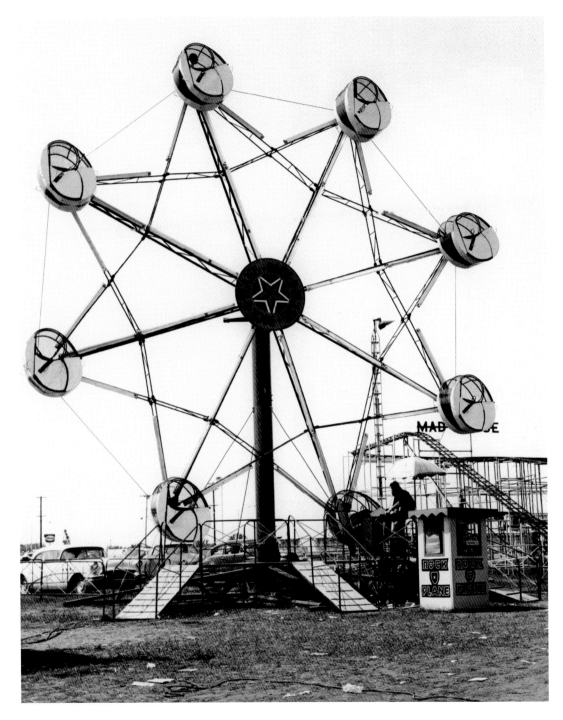

Ferris wheel, Collins Shows carnival. 1961

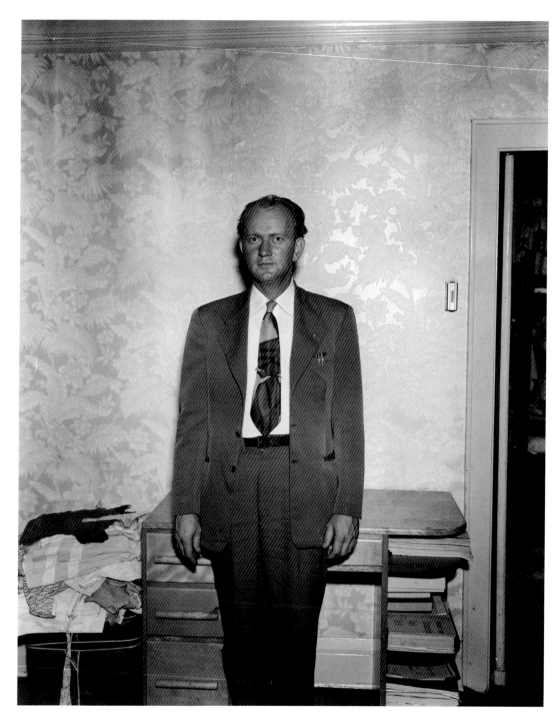

Gene Payton (Norling's first flash photo). 1949

Rev. Kingswriter and Curt Carlson, old Kimball School, 86th Street and Cedar Avenue. 1956

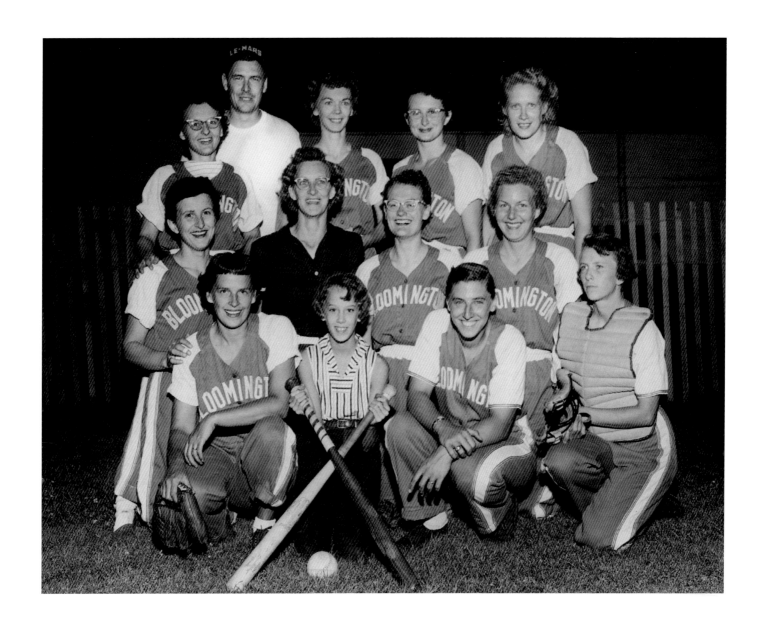

Walsh's female softball team. 1957

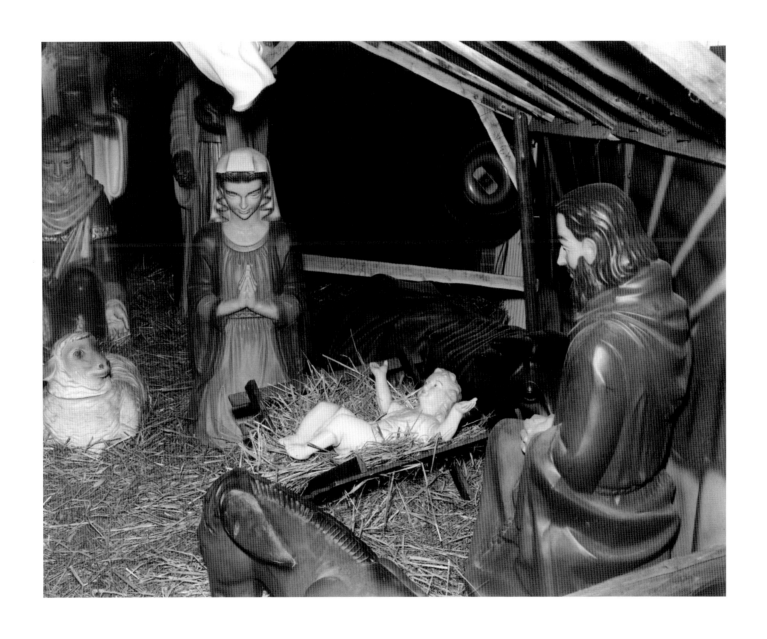

Nativity scene, Atonement Lutheran Church. 1957

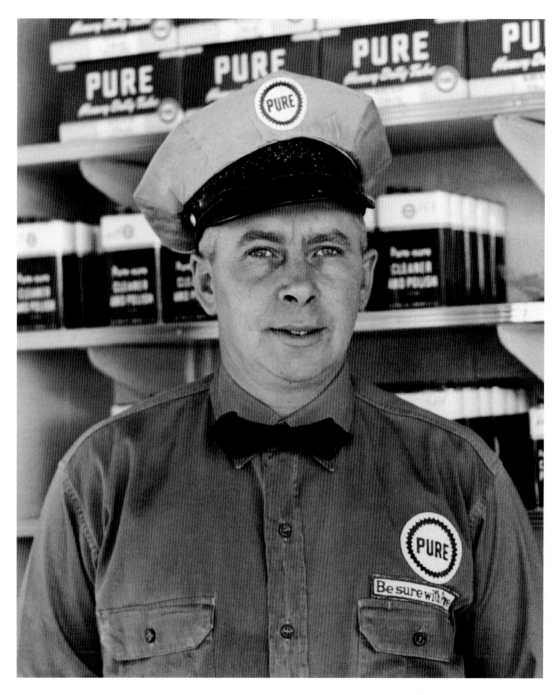

Howard Elka, manager, Pete's Pure Oil. Cedar Avenue and Old Shakopee Road. 1956

FACING PAGE: Camera store manager, Hennepin Avenue, Minneapolis, circa 1955

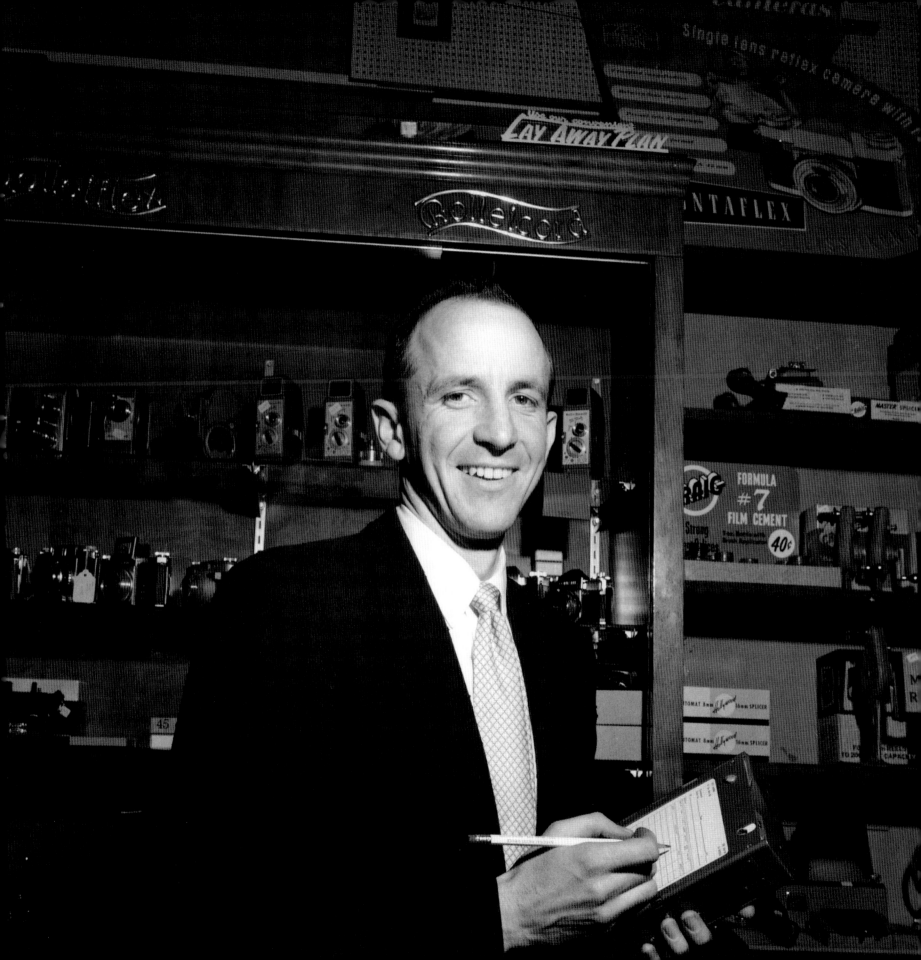

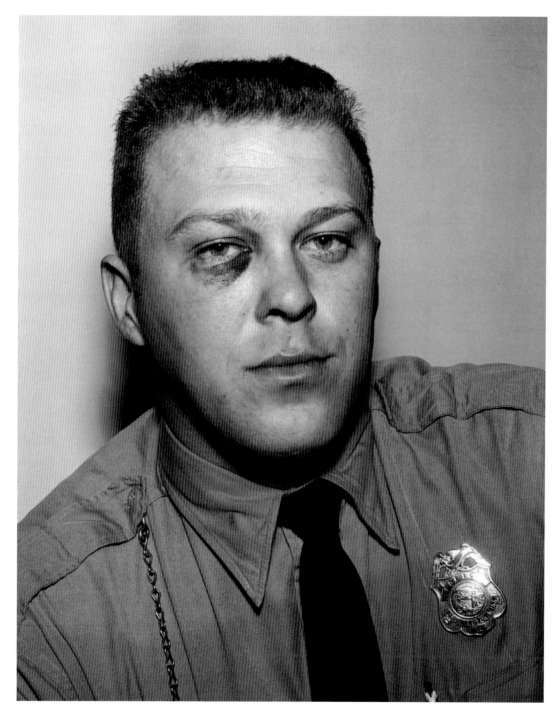

BPD officer Richard Hauck. 1960

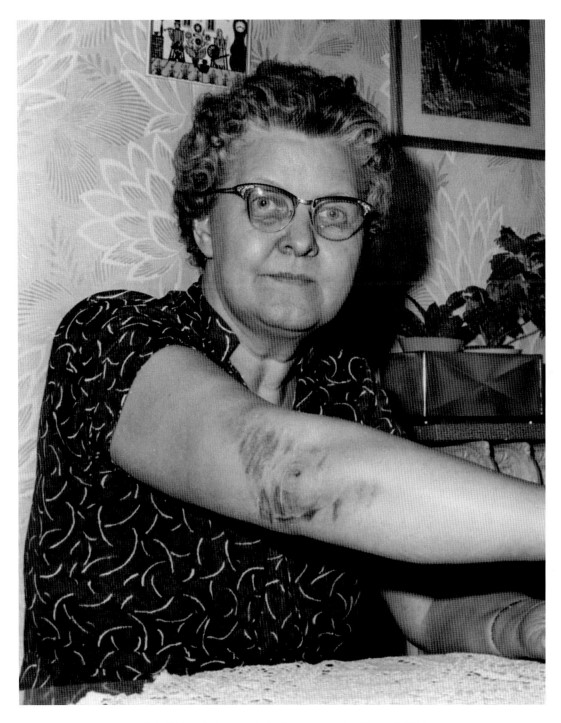

Mabel Edquist displays injuries (photo taken for attorney). 1960

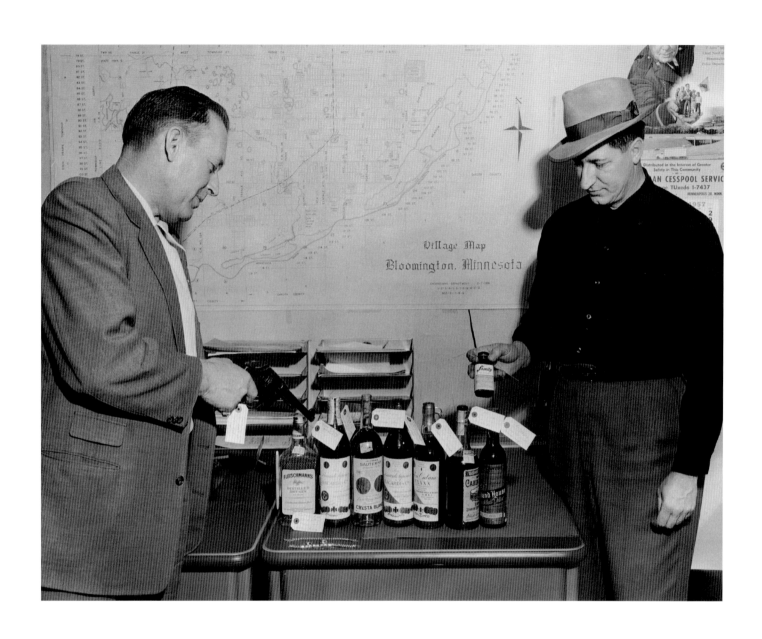

BPD officers with recovered loot. 1957

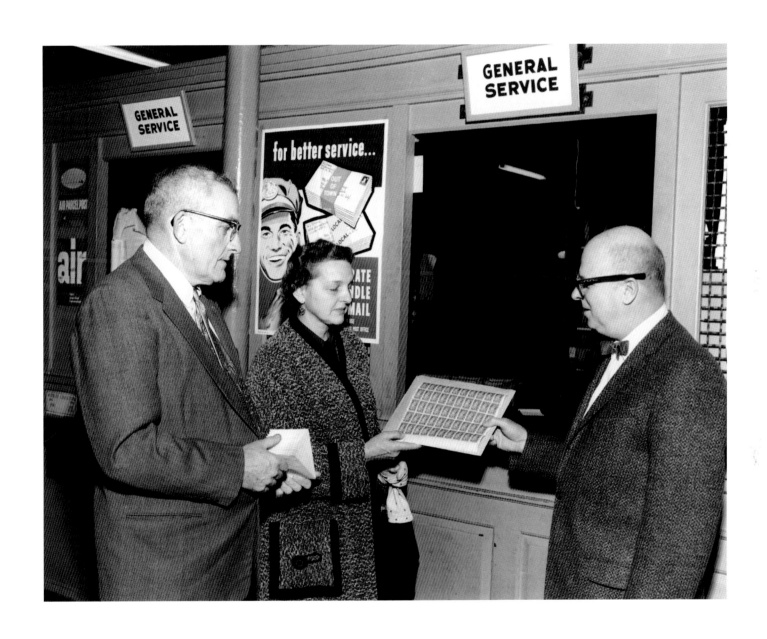

Bloomington Post Office. 1958

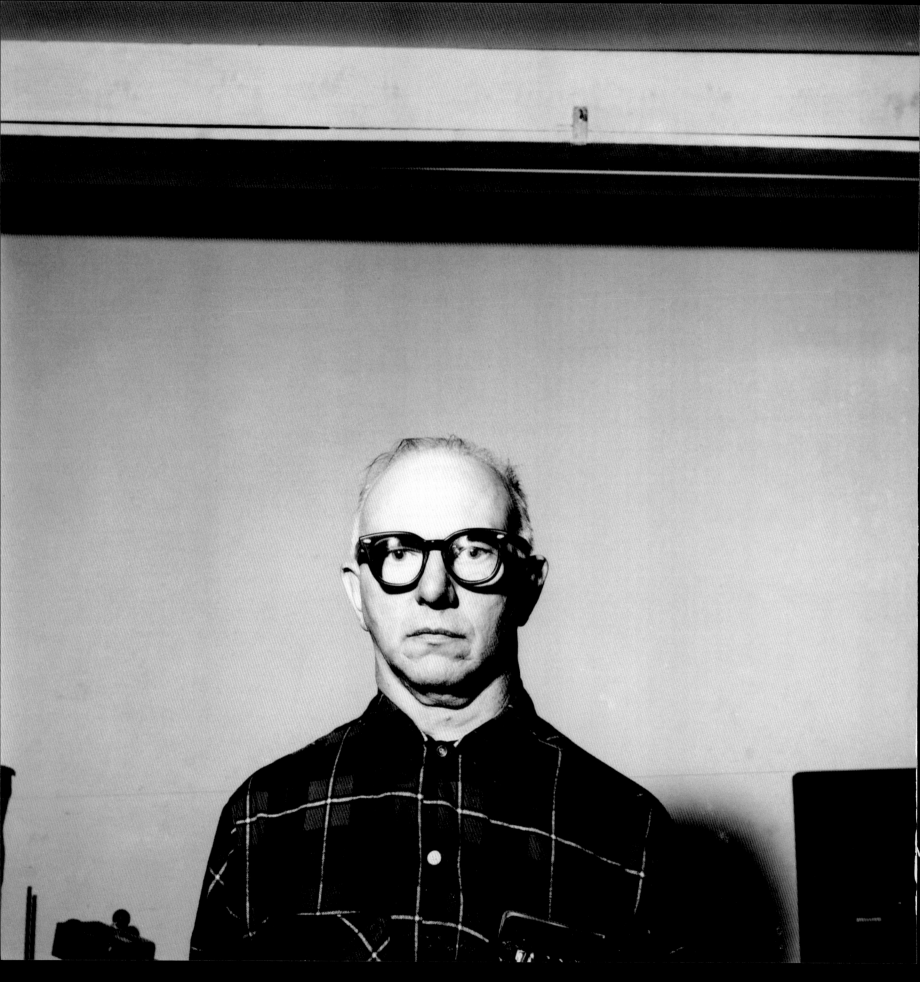

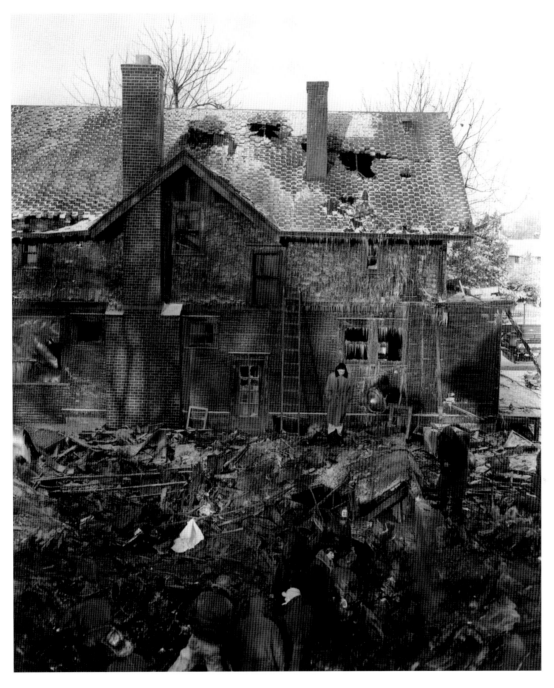

Plane crash, Dupont Avenue and Parkway. 1950

FACING PAGE: Irwin Norling, circa 1959

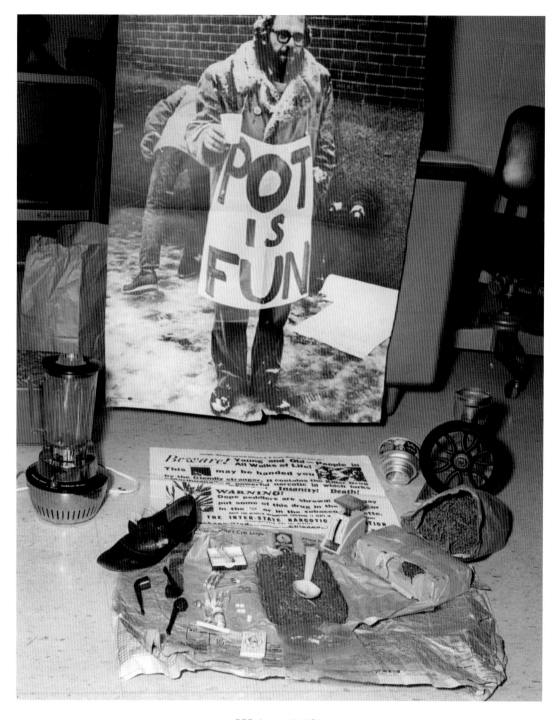

BPD drug raid. 1969

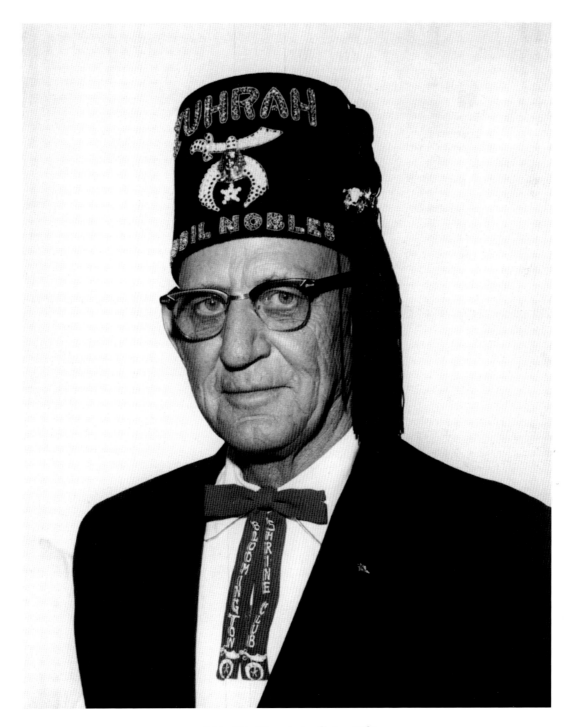

Unidentified Bloomington Shriner. 1965

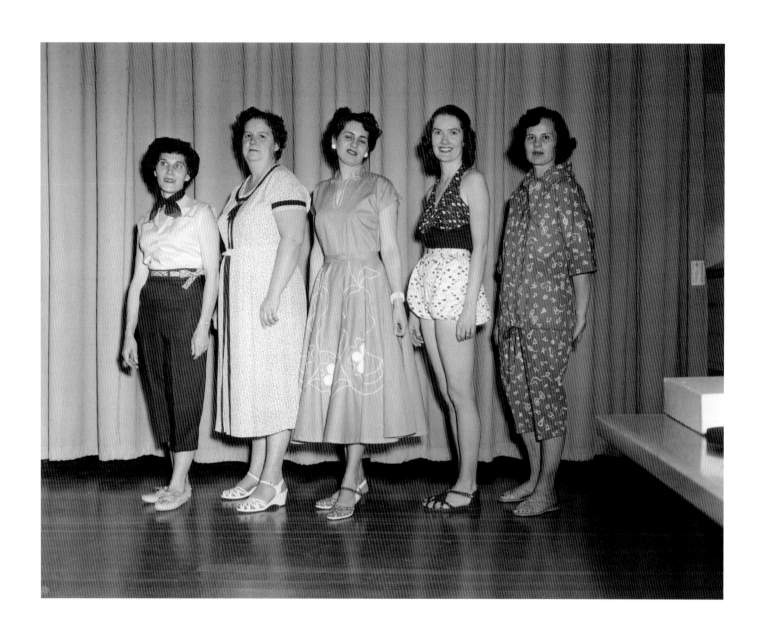

Riverside Mother's Club style show. 1955

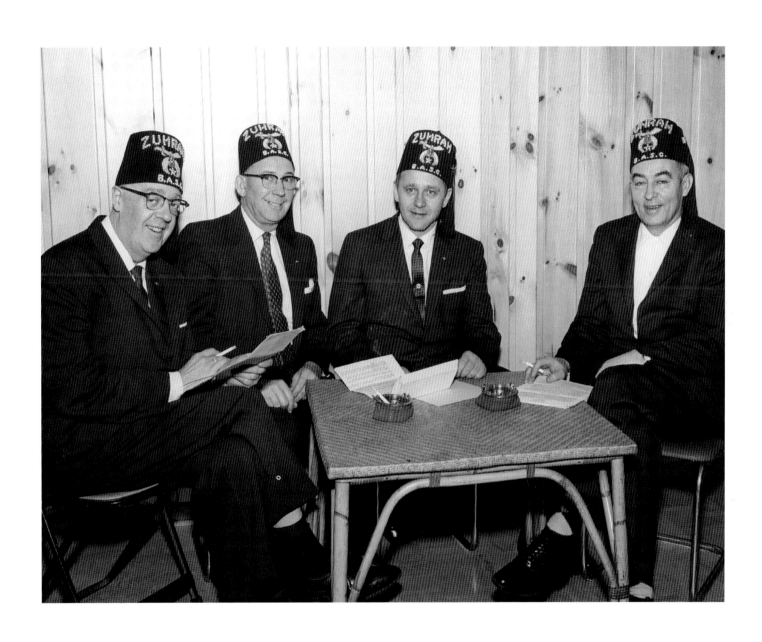

Bloomington Shrine Club officers. 1960

BPD evidence photo, circa 1963

FACING PAGE: Water safety program; Willy Water with beauty queen. 1969

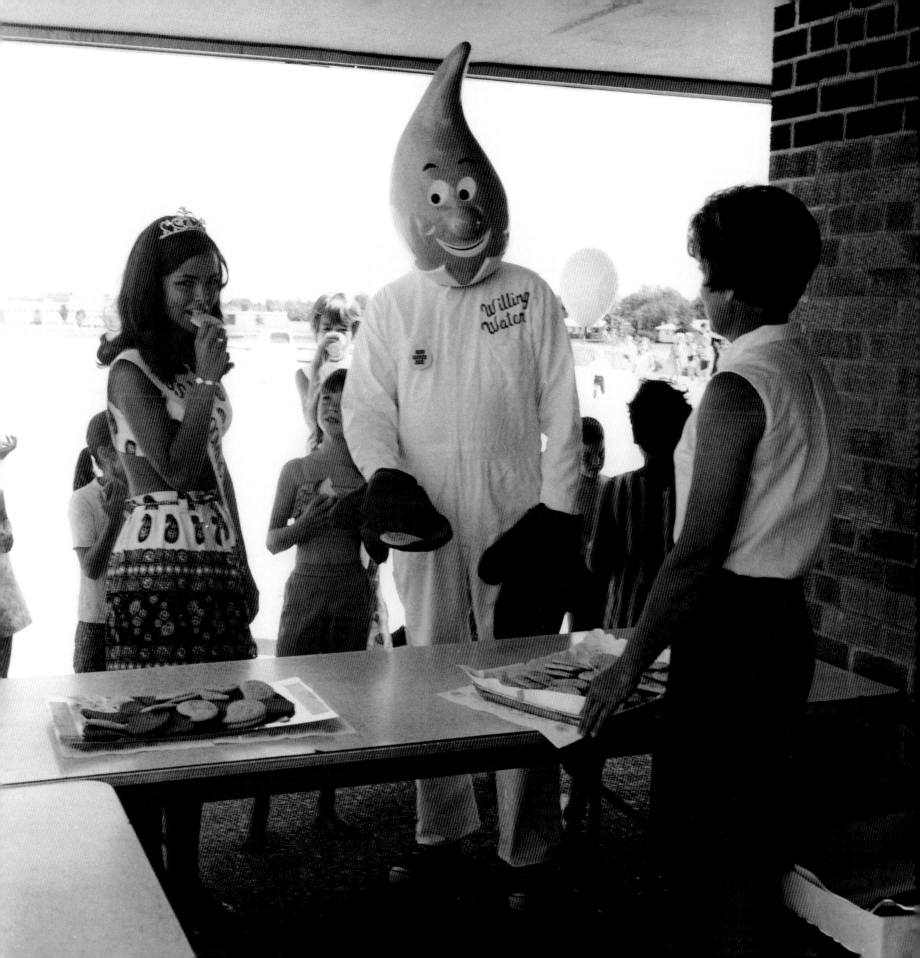

Bloomington Kennedy Senior High School dedication. 1965

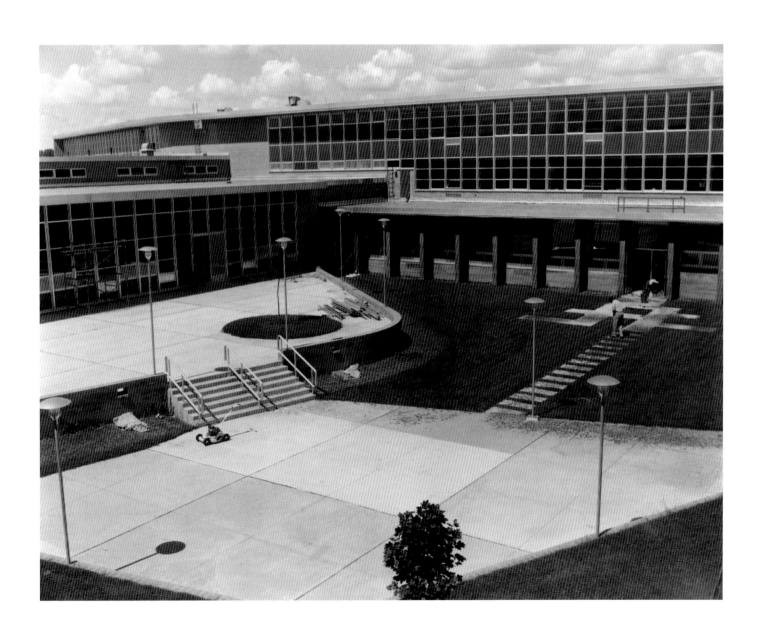

Bloomington Lincoln Senior High School courtyard. 1957

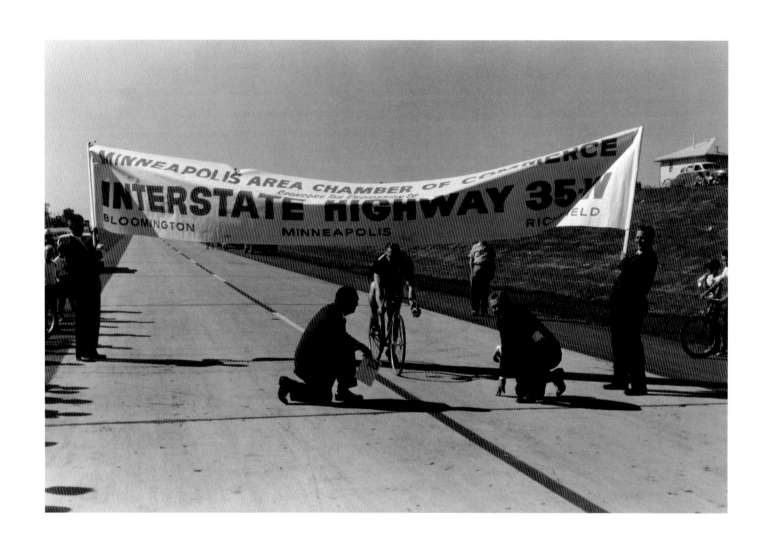

Opening of Interstate Highway 35W. 1955